MIKE MAC'S
WHITE AND BLACKS
PLUS ONE COLOR

MICHAEL McCARTNEY
Foreword by David Puttnam

PENGUIN BOOKS

FOREWORD

My father was a photographer and I was brought up during the fifties in a settled, middle-class environment.

These are just some of the reasons for my finding a compulsive interest and identity in these photographs. Add to this the fact that I am an exact contemporary of the lads immortalized (once again) on these pages, and that nowadays I share a career with George, a friendship with Paul, a continuing admiration for John and an affection for the author–photographer which goes back more years than I am prepared to concede, and I hope that I have adequately explained what I am doing on this page.

Mike's photographs precisely mirror the place and time in which I struggled through adolescence. It's difficult to describe the shock of recognition, not just in the haircuts, clothes and instruments but, more importantly, in well-remembered sofas, curtains and even wallpaper. There is something indefinable about these 'snaps' that allows me renewed access to the smells, sounds and sensations of the years that formed me.

This book is a very special time machine, an essential indulgence for all those who lived, or wish they had lived, through that era.

David Puttnam

INTRODUCTION

In 1985 I was asked by the American Society of Magazine Photographers, 'Are you a photographer?' In all honesty I had to answer, 'No.' On the other hand, anyone who picks up a camera and takes a picture is a photographer, particularly as each progressive stage of automation makes it easier for even a novice to take a good picture these days.

I answered 'no' for the simple reason that I wouldn't dare equate myself with someone whose whole life has been dedicated to the art (because an art it certainly is) of photography. However, the majority of the pictures you are about to see were taken many years ago at a certain height of awareness when I had the *time* to pursue the intense interest and love of my main hobby, this thing called 'photography'.

Back in the early sixties I had the audacity to develop and print my own photographs (which was absolute magic...in fact Rollei Magic) and I couldn't have been all that bad at it, as the negs have actually survived until today.

I certainly hope you enjoy the images coming up, and it may sound daft but I'd also like to thank you because compiling these photographs for you has reactivated my interest in taking pictures and I've started to 'see' again (photographically speaking, that is).

Ta very much and for God's sake don't buy this book or I'll have to do another one!

There aren't many, if any, people I would trust with my old negatives but Mr Terry Cryer, master printer, Leeds, Yorkshire, is the exception. He not only looks after and takes care of my old (and now new) memories but also refuses to print any images which are not up to standard! In fact sometimes getting prints out of him is like trying to get water out of a brick.

A good photographer in his own right, Terry is one of the country's best photographic printers and I'd like to thank him for his patience and skill with some of my old negatives – 'Some badly kept,' said he. 'Nearly as bad as my own.'

PENGUIN BOOKS
Viking Penguin Inc., 40 West 23rd Street,
New York, New York 10010, U.S.A.
Penguin Books Ltd, Harmondsworth,
Middlesex, England
Penguin Books Australia Ltd, Ringwood,
Victoria, Australia
Penguin Books Canada Limited, 2801 John Street,
Markham, Ontario, Canada L3R 1B4
Penguin Books (N.Z.) Ltd, 182–190 Wairau Road,
Auckland 10, New Zealand

First published in Great Britain by Aurum Press Limited 1986
First published in Penguin Books 1987

ISBN 0 14 01.0251 5
Library of Congress Catalog Card Number 87-040063

CIP data available

Printed in Italy
by A.G.V., Vicenza, Mondadori Group
Set in Linotron Helvetica

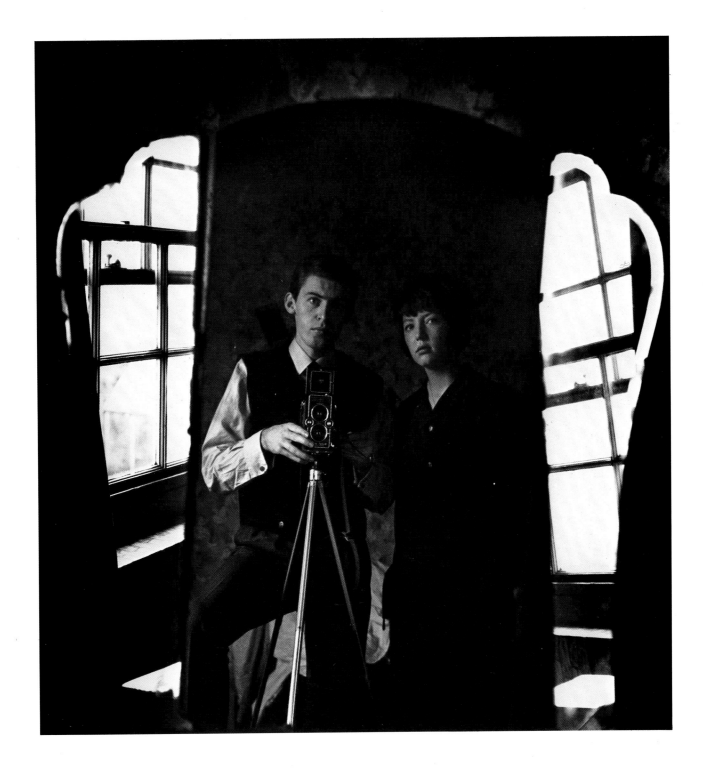

Malice through the looking glass

A young Michael and Bobby fan club in 1962, with the camera that took most of these images, my Franke and Heidecke Rollei Magic, 'experimenting' in the back bedroom of our home in Allerton, Liverpool. As there were no Brandt, Bresson or Bailey videos on photography back in the late fifties, I had to learn the hard way…by reading as many books from the library as I could lay my hands on. To get this shot (although not recommended, so the books said) I angled the side mirrors to catch all the light from the window.

'Boy Paul' blowing up Hot Dog Corner at Butlins holiday camp, Pwllheli, North Wales

How I managed to convince my canny father that I could be trusted with the valuable family camera I will never know, but this was one of my first shots taken on our Kodak box camera (c. 1954). Always a man of great taste and foresight, it is obvious that Dad realized even then that I would become one of the world's great, even if not greatest, photographers.

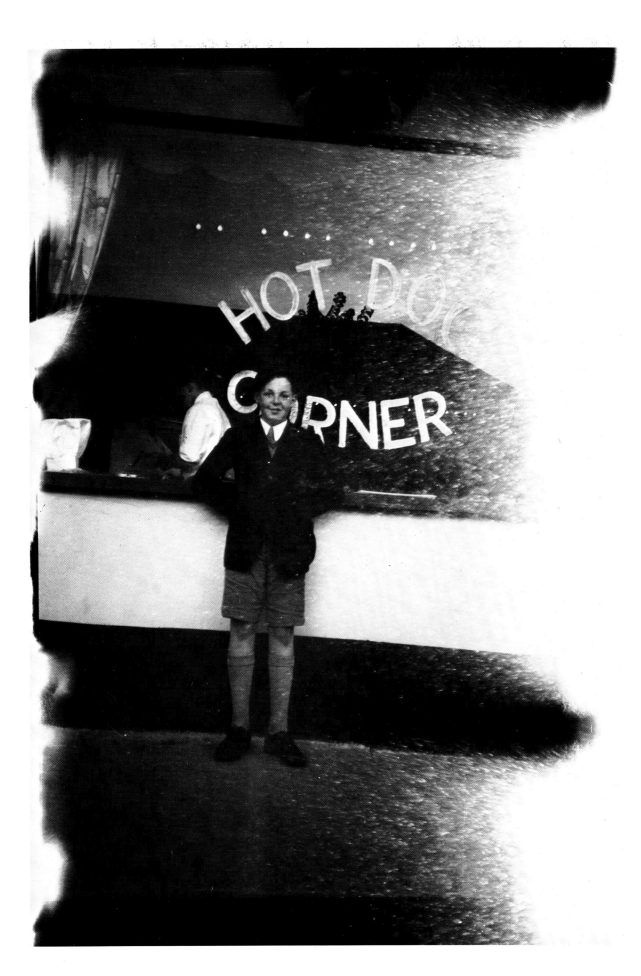

First portrait: a young George 'Teddy Boy' Harrison (plus Tony Curtis D.A. haircut) in desperate need of the sea

The realization that there was more to taking pictures than meets the eye came about one clear summer morning before school in the back garden of our Allerton home. Although it was nowhere near the sea, or even the River Mersey, a flock of seagulls had flown inland and were swooping over the garden. Borrowing the family box camera, I crept quietly into the garden, waited until two of the largest seafaring creatures swooped very low over my head, and clicked the shutter for posterity. When the prints came back from the chemists and I proudly showed them off to the family, all that could be seen of the giant seagulls were two distant minute specks in the middle of an enormous blank sky. From birds I quickly progressed to people... they were nearer and bigger.

Overleaf left: Landscapes

Queen Elizabeth II (which, so they say, eventually burnt and sank to the bottom of Hong Kong harbour) sailing past cousin Bett and Mike's pub in Ryde, on the Isle of Wight.

Overleaf right: Waiting for the big sail-past outside the Bow Bars with cousins Ted and Kate Robbins in the window

My summer job in Ryde was Hamburger King of the Isle of Wight. It was in this bar that I offered the management of the Beatles to one of the Jones Boys, as he was married to the biggest singer of the day – that lovely gravel-throated Belfast colleen, Ruby Murray. He turned the offer down and Brian Epstein got the job.

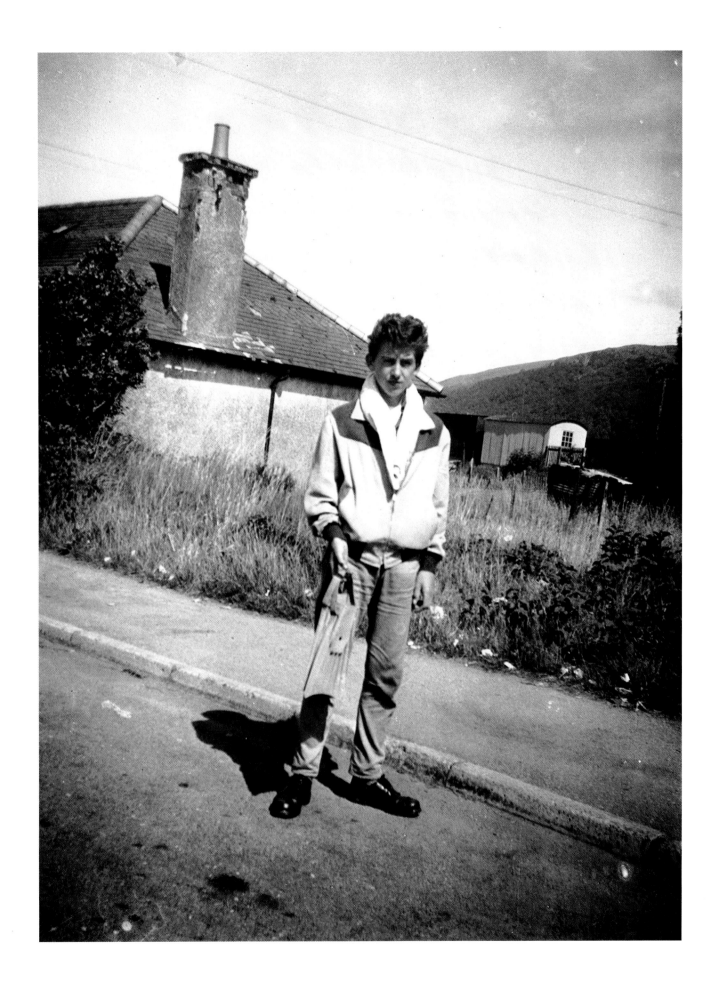

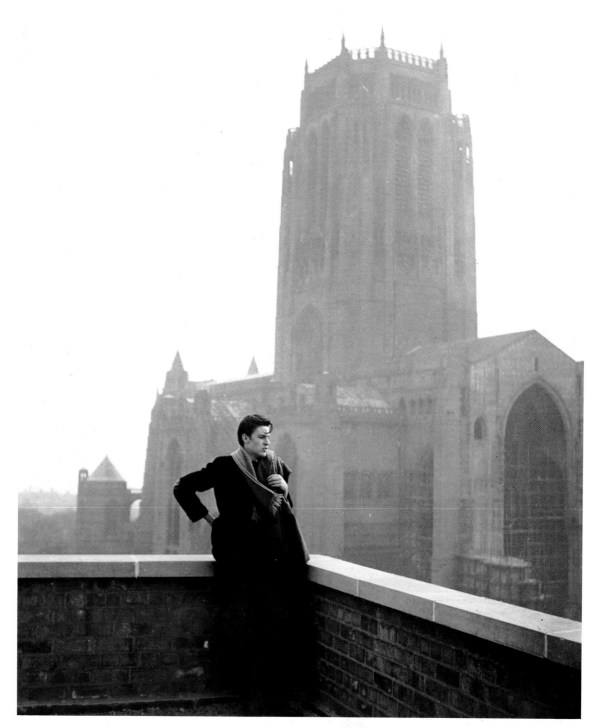

Self-portrait on the nearly finished roof of the art school extension, Liverpool, with an unfinished Metropolitan Cathedral as backcloth

For self-portraits, or photographs with me in them, I would simply set up my camera on its tripod, frame the picture and then ask a schoolfriend, brother, roady etc. to press the cable release.

Right: The Liverpool Institute High School for Boys (the 'Inny')

Taken in my Lowry period, this picture of the lower and upper play yards features the notorious smokers' corner at the end of the long corrugated roof.

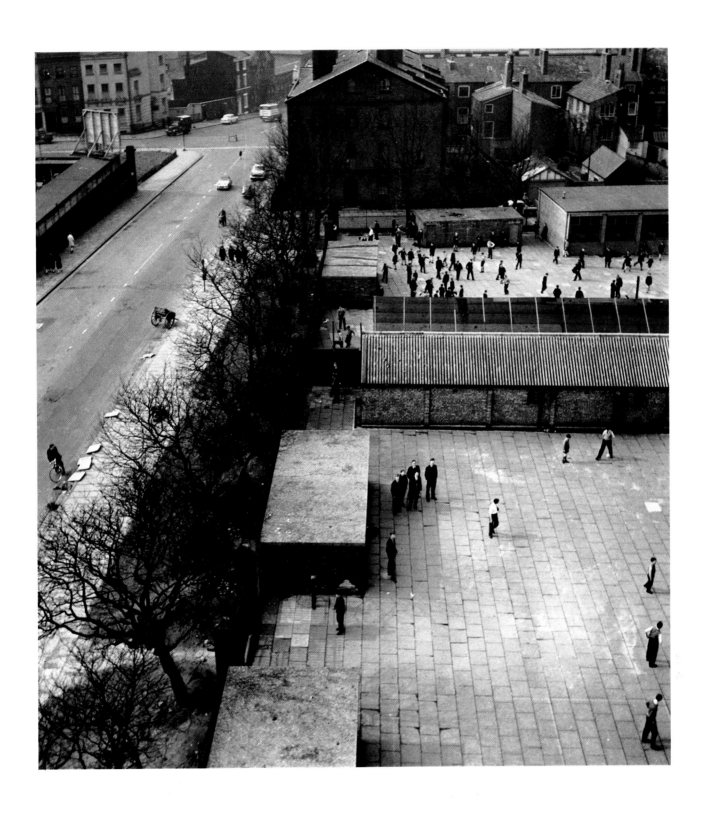

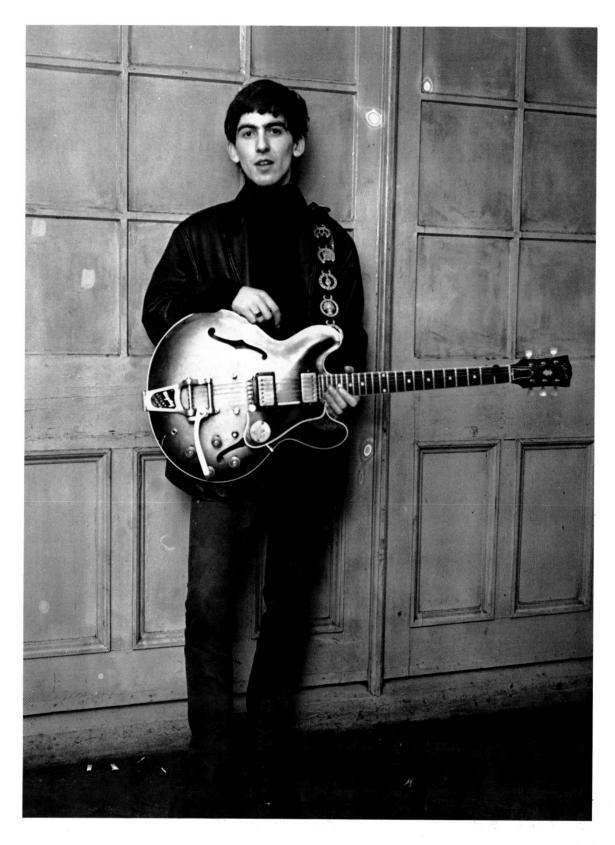

'Quick Mike, take a picture of me with Joe Brown's guitar, before he comes back from the bogs'

Taken between performances of Joe Brown and his 'Bruvers' and the Silver Beatles at the Tower Ballroom, New Brighton.

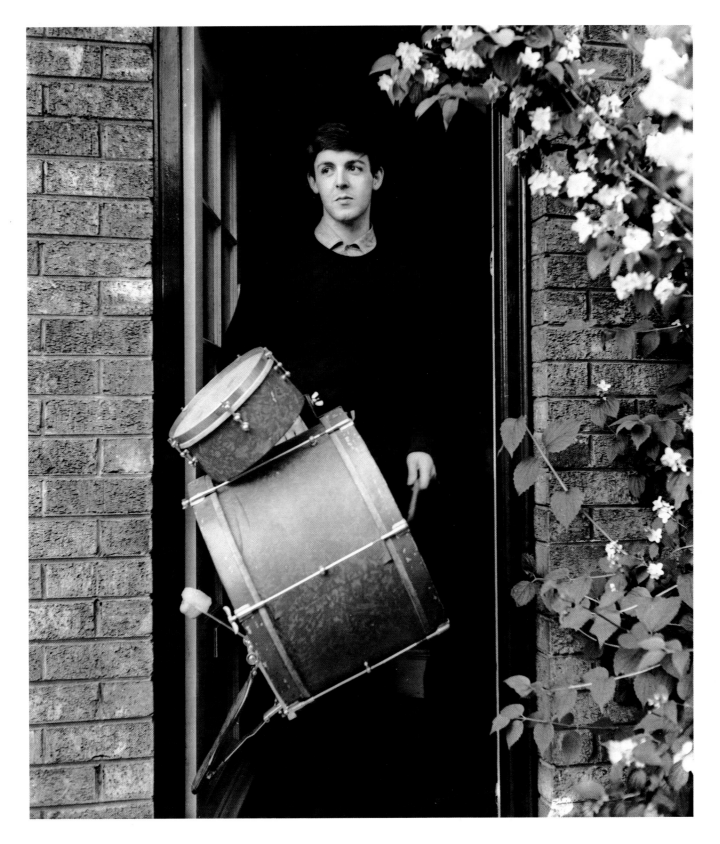

**'The little drummer boy' with my drums at the front door
of our Allerton home**

The drums were last seen, nicely lit, on a stand in Beatle City,
Liverpool, labelled 'Paul McCartney's drums'!

The back jigger (entrance) to our home in Western Avenue, Liverpool

When we were old enough and *big* enough we would flatten our backs against the alley wall and, stretching our legs to the other wall, slowly edge up to the roof of the entry. There we would wait until it got dark, when we would drop like stones on to any calling friends with loud, blood-curdling screams! Not many friends called round to No 72.

Right: A young reflective Peter Michael McCartney playing with the light in our Forthlin Road back bedroom

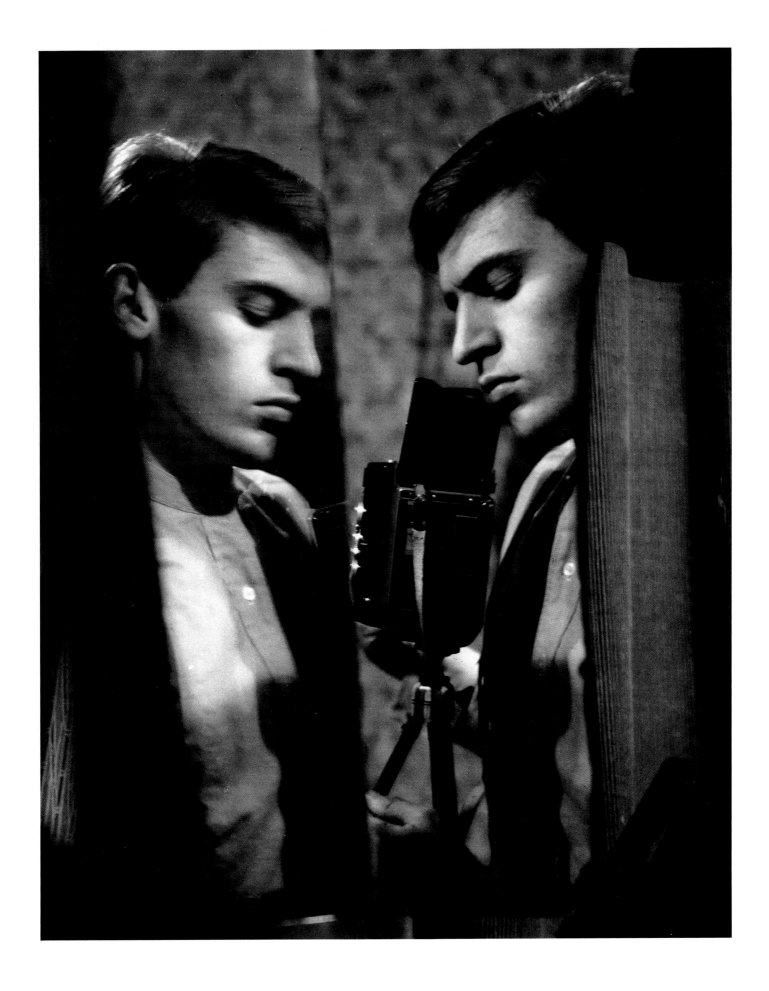

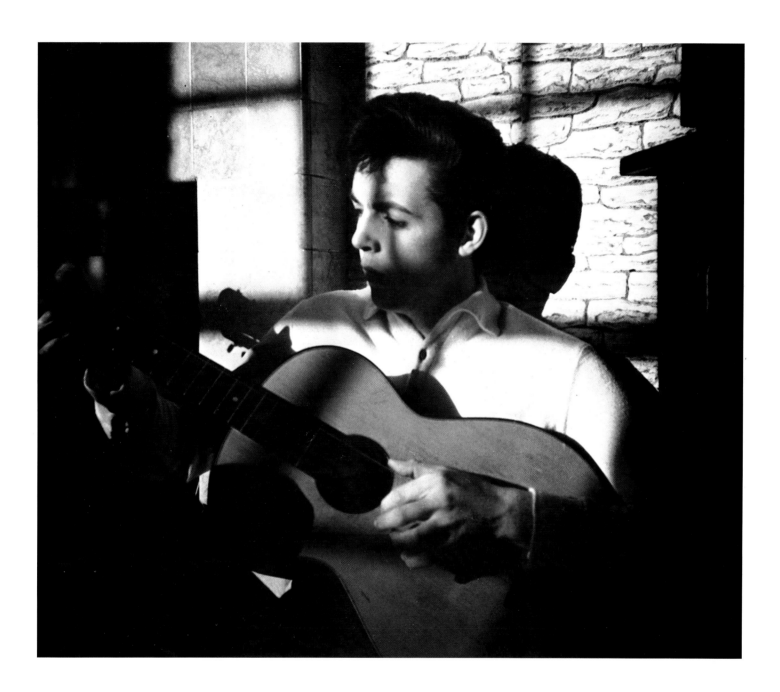

Young man in bright sun with first guitar against false brick wallpaper

Another 'rule' that I broke was 'Never photograph people in bright, head-on sunlight'. I'm glad I ignored that, as I quite like the mood of this shot taken in the front parlour of our house in Allerton. If she had been alive I don't think Mum would ever have allowed 'the boys' to get away with ordering *three* different wallpapers in the one room! (Keep turning the pages for the other two wallpapers.)

Left: 'Observing' Kingsley Amis

Quite contrary to the dumb Liverpool working-class myth of the McCartney family, we used to get and enjoy the *Observer* on Sundays, and Dad even managed to complete the crossword every weekend.

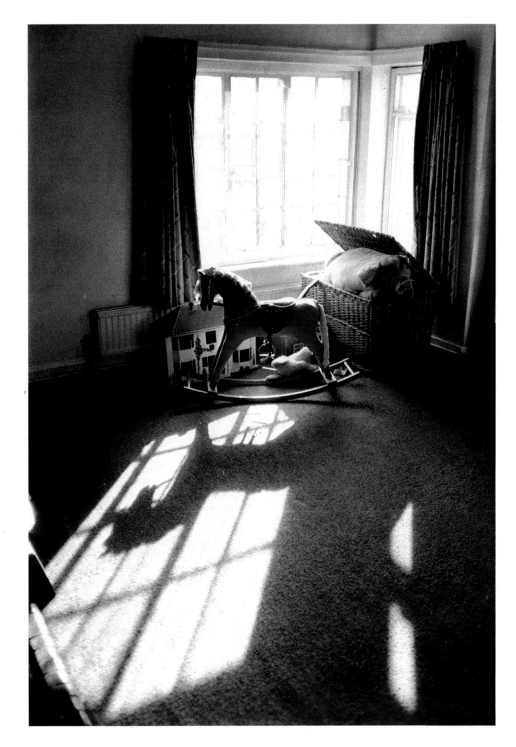

Still Life 1: Enormous big pig squeezing desperately into wicker basket and rocking horse about to attack and devour toy house

And you thought it was an innocent sunlit picture of Rowena's cuddly toy pig in its Fortnum & Mason basket with Josh's corduroy rocking horse in our picturesque 'Sunset' over the water home … didn't you?

Right: Still Life 2: Baby Josh, taken in my Dutch Masters period

'I suppose the guitar got there by accident?' remarked Sir Bob Geldof.

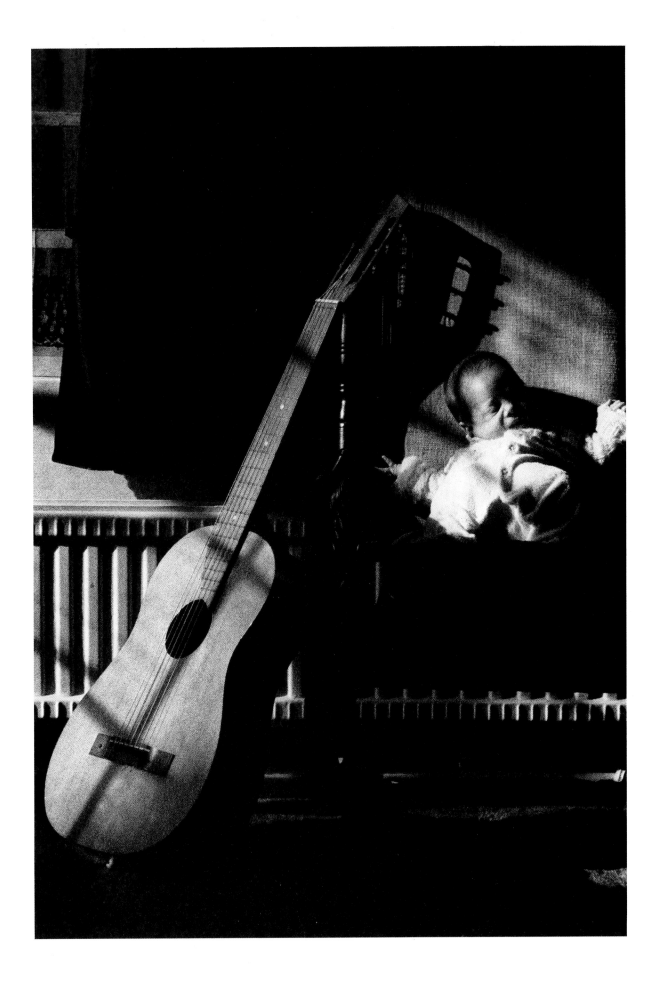

Peroxide blonde upstaging two Silver Beatles

Happy George, and Paul with upside-down, three-piano-wire-strung 'Solid 7' guitar (with that web they should have been called 'The Spiders'). Taken in the basement of Mona Best's home in Haymans Green, West Derby, Liverpool, which she turned into the Casbah Club for her son Pete to practise and later perform in together with John, Paul and George. I personally like this portrait of George as there aren't too many photographs of him smiling, but when he does he lights up the page.

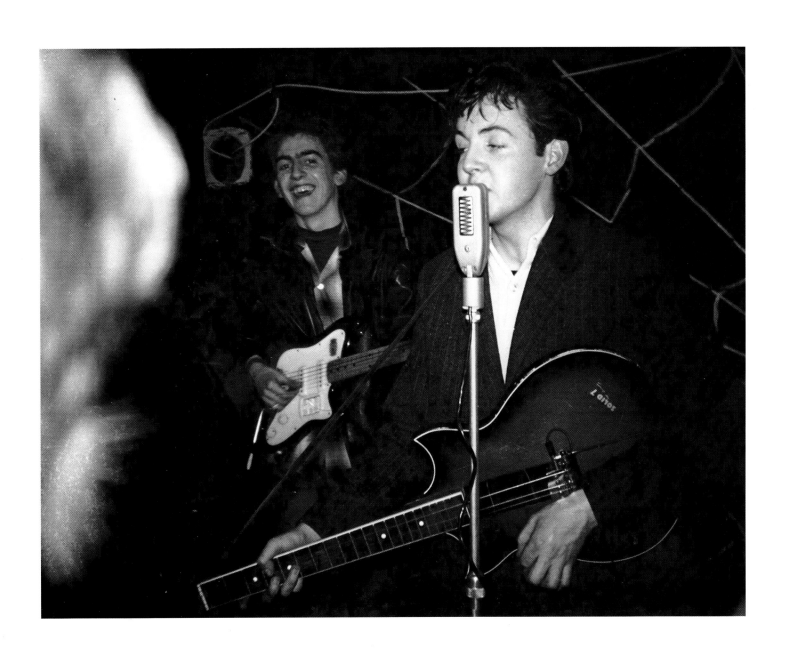

The Fab Two through a Cavern archway

A more serious George plus out-of-focus Paul, taken from the side of 'The Cave', practising in that rotten food smelling cavern underneath Mathew Street in Liverpool City Centre.

In 1984 an enterprising company tried to rectify the major blunder made by the local council several years earlier (when they had filled in the Cavern) by rebuilding the place. They started well by building *on* the actual site in Mathew Street and continued with a good example of modern architecture called Cavern Walks, but they made one small mistake when it came to the Cavern … it's the wrong way round!

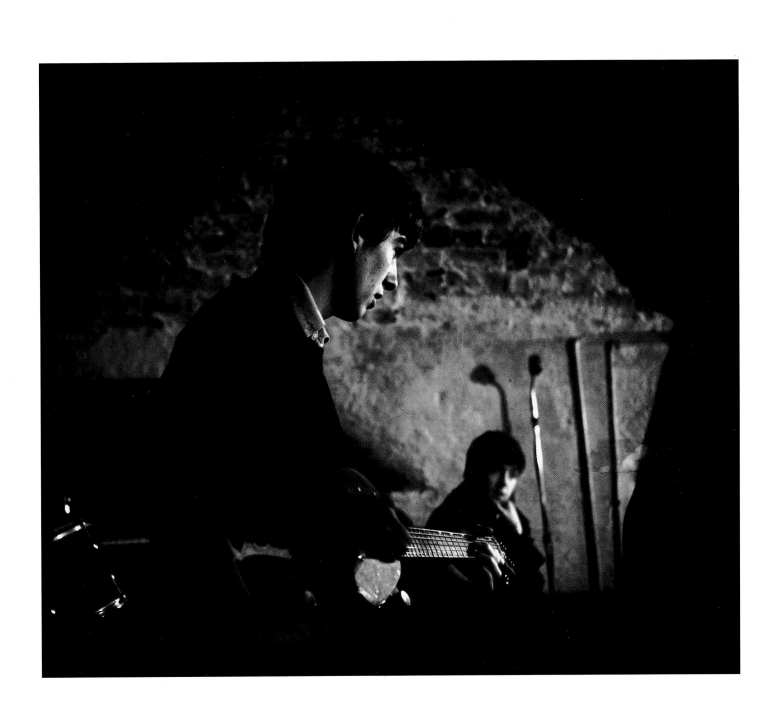

**Early morning window shopping for winkle-pickers after
a Cavern 'All Night Session'**

Waiting for the first No 86 bus home, I took this photo in the doorway of
a deserted shoe shop window in Lord Street, Liverpool. It's one of the
few unchanged shops in the city, so if you are ever passing through 'de
Pool' (as we Liverpudlians call her) you too can have your pic taken
through the same side window. The only thing that will have changed
is the winkle-picker shoes.

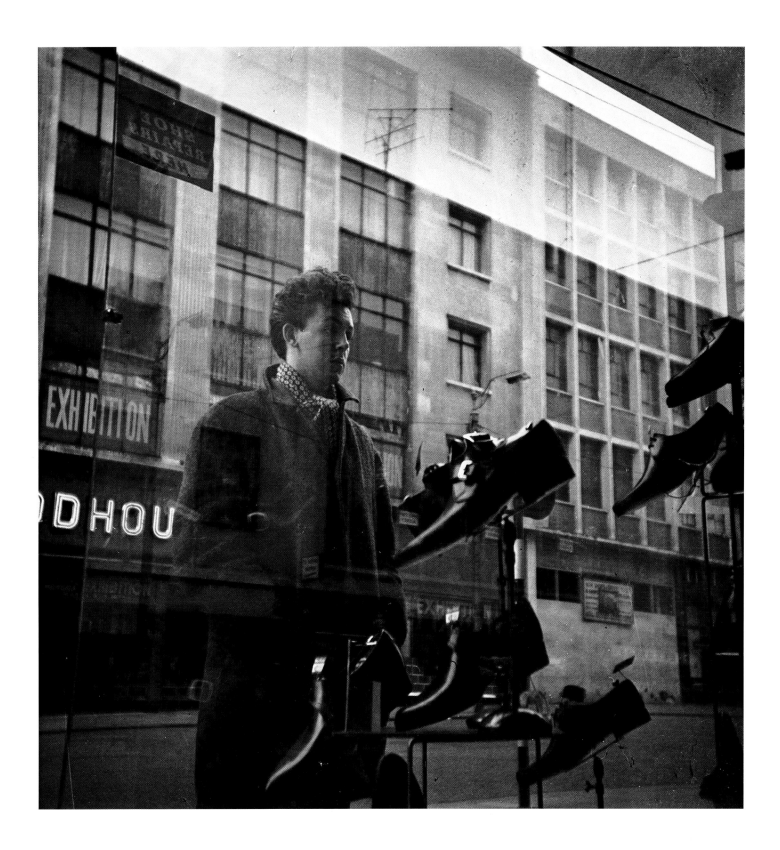

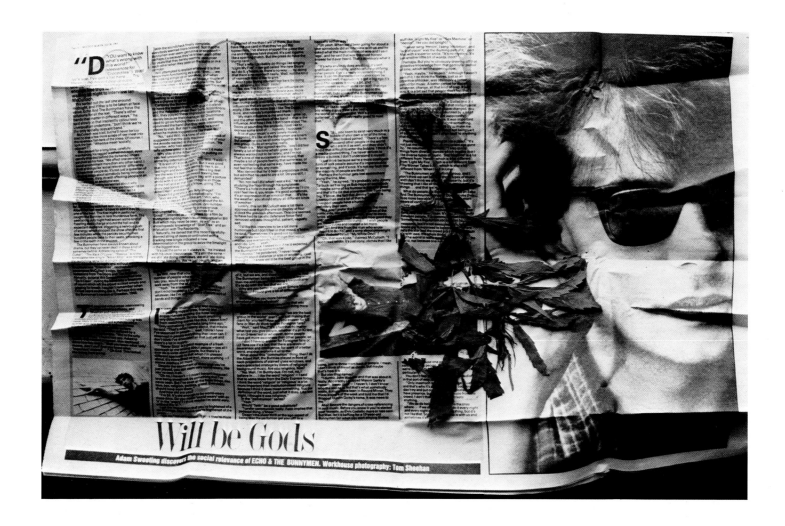

Paper Pictures 1:

Gods
Will be Gods

Will we?
We will be Gods

An image taken at a writer's home of drying leaves – probably mint –
on an article about Echo and the Bunnymen, one of the best new solid
groups to come out of Liverpool today. Instead of the old Merseybeat
groups, the Bunnymen list as some of their influences The Doors and
Leonard Cohen … to name but three.

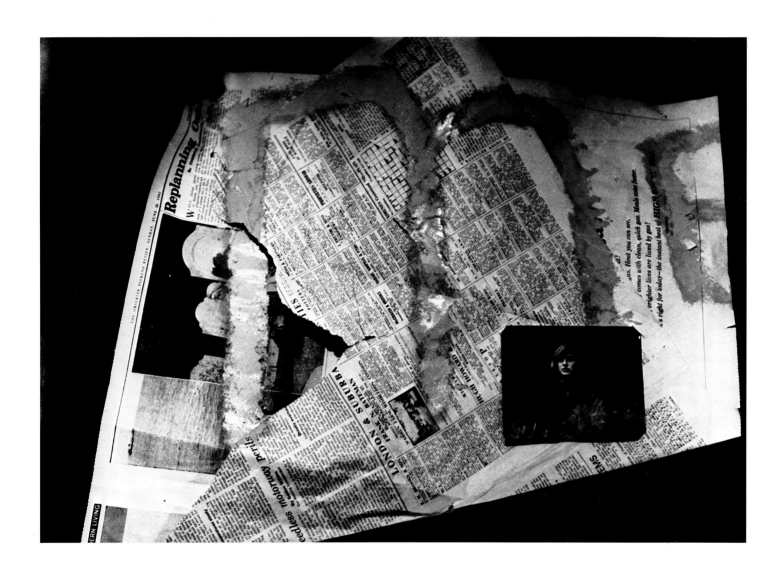

Paper Pictures 2: Me and Ursula

Photograph of a paper painting hanging on the wall of our Merseyside home 'Rembrandt', including one of Dad's crosswords. My cousin Bert Danher, Annie McCartney's son – who by the autumn of 1986 will be the only man in the UK to represent all five quality British newspapers: *The Times, Telegraph, Guardian, Financial Times* and the latest *Independent* as crossword boss – informs me that crosswords were introduced in 1913 from America by a Liverpudlian, one Arthur Wynne, who emigrated to the States and worked on the New York *Sunday Word* supplement *Fun*, and were originally called word-cross puzzles.

Four shiny black Beatles with instructions from me to 'All look at the light bulb' ... *two* got it right

To stand out from such safe, bespoke-suited performers as the Shadows, Craig Douglas, etc. the Beatles had adopted their Marlon Brando style motorbike leathers from Hamburg, which *looked* magnificent but made them sweat like pigs on the oven-like Cavern stage. This was taken in the Cavern drezzy (dressing room) just prior to climbing the stone steps on to the stage.

Overleaf left: Big John, Gene Vincent and brother Paul

One of the strange things about the Cavern was that when there were groups on and you entered from the cold raining street, went down the steep, often slippery wet steps into the boiling hot cave, through the sweating, body-filled dark archways and finally into the dressing room, the contrast was extraordinary – you were back in the cold again. As you can see from this picture with Gene Vincent and the lads waiting to perform, the electric fire is on!

Gene was one of our early rock and roll heroes who not only impressed us by wearing full-length black leathers, but more important he had heard about the Beatles and was anxious to meet them. Praise indeed from a boss rocker! To mark such an auspicious occasion, I asked Gene to pose for me next to Bob 'Big Beat' Wooler's corner (right of picture). Sounds Incorporated are on stage.

Overleaf right: Gene Vincent live on the Cavern stage

Taken from the back of the Cavern at the top of the steps (built by Uncle Harry and cousin Ian), zooming past Gene in a typical 'Be Bop-a-Lula' pose, this picture is stolen by the Cave kids, waiting for their Liverpool heroes. The fans would not only copy the Fab Four's stage gear, but also the striped shirts they wore off stage.

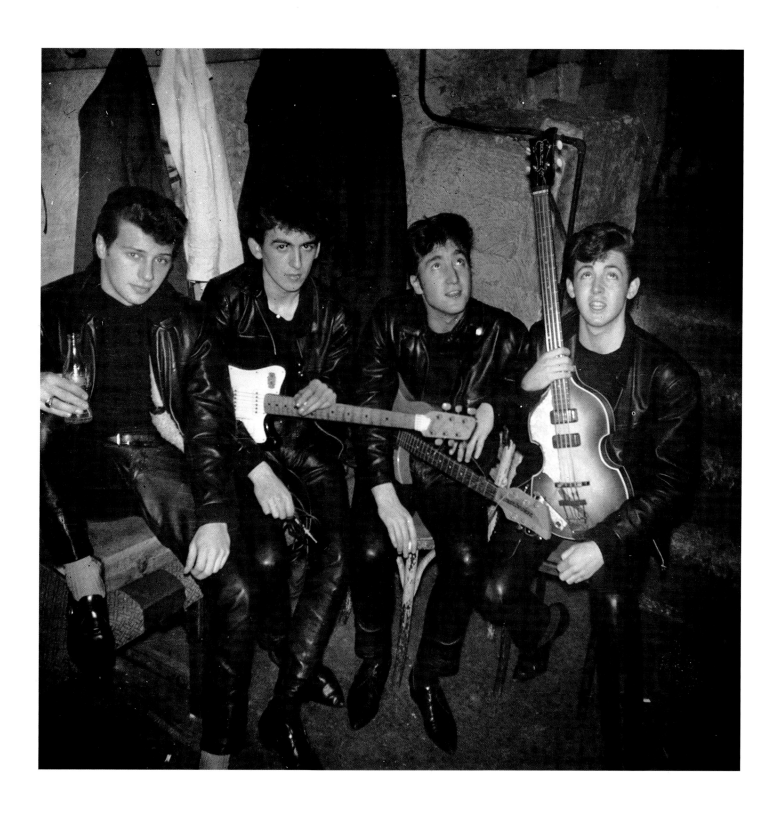

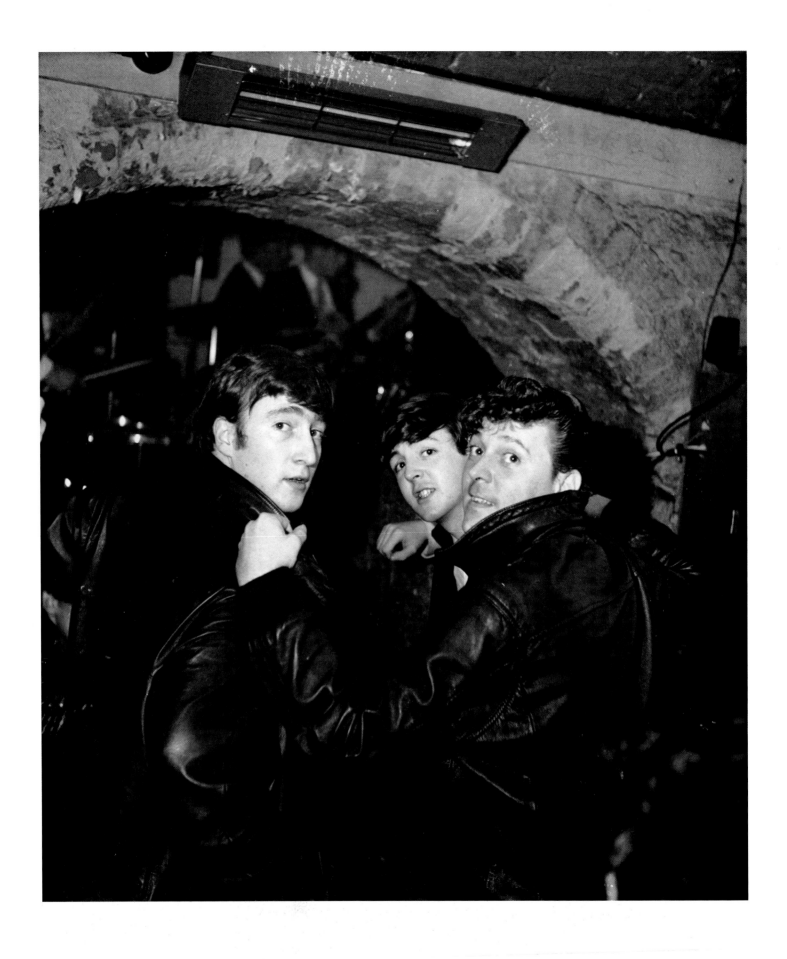

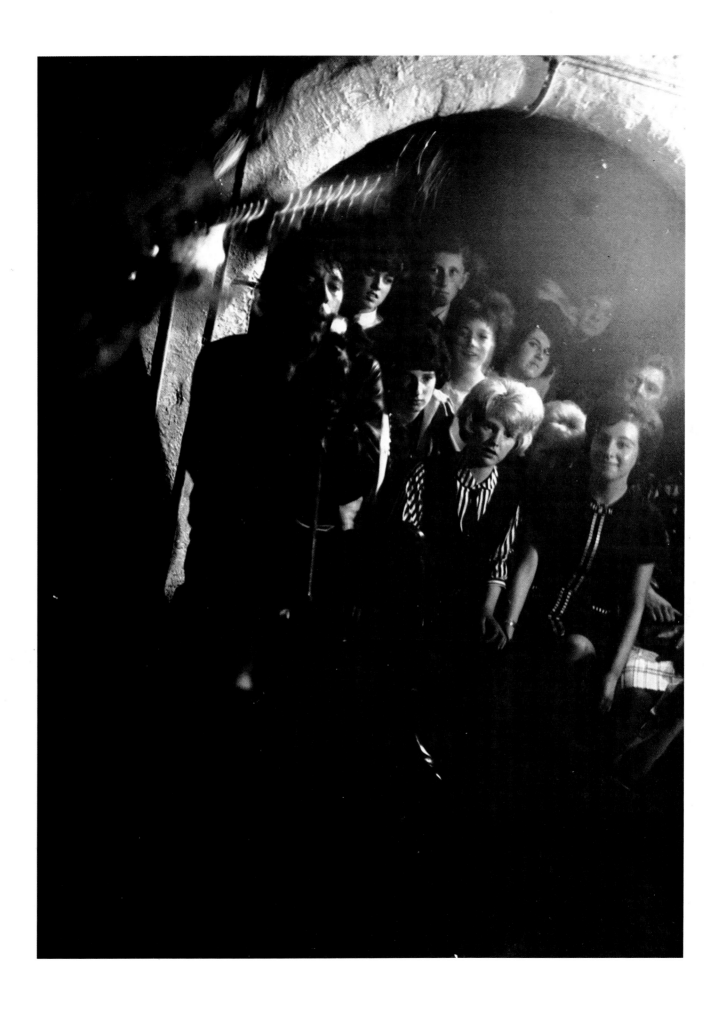

'I wuz framed,' said idol convict GAR 6922

Little did the fans know that the striped shirts they copied were themselves copied by us from the satirical television series 'That Was The Week That Was' starring David Frost.

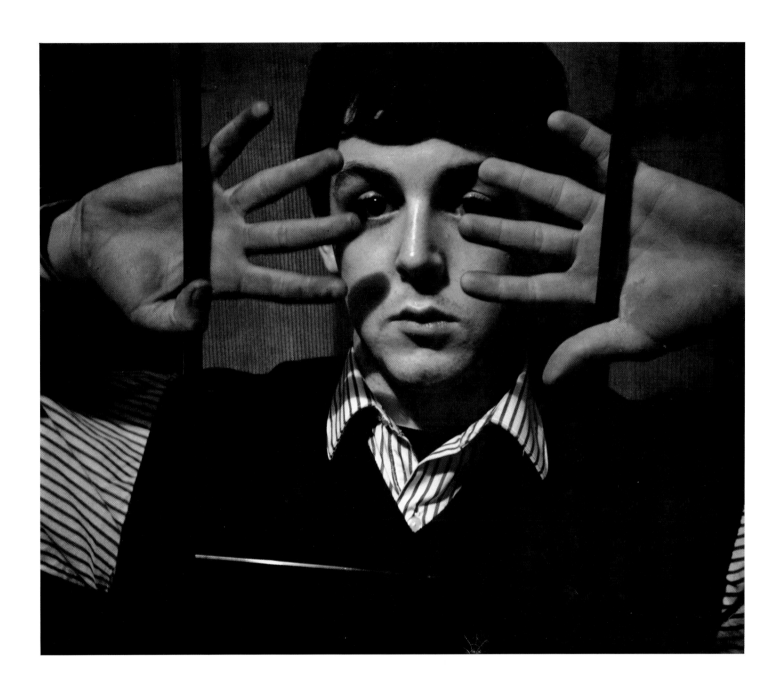

Michael Magritte growing out of his bedroom floor (first attempt at photo surrealism)

An experimental shot with the Rollei placed flat on the floor and the mirror tilted up to expose my hidden shameful secret! As there were no Rotary Glazers to dry my prints in the early sixties (or if there were, I certainly couldn't afford one) I used to peg out my 2¼ inch negs and prints to dry on a string across my bedroom, using hairdressing clips from André Bernard's where I was apprenticed as a ladies' barber.

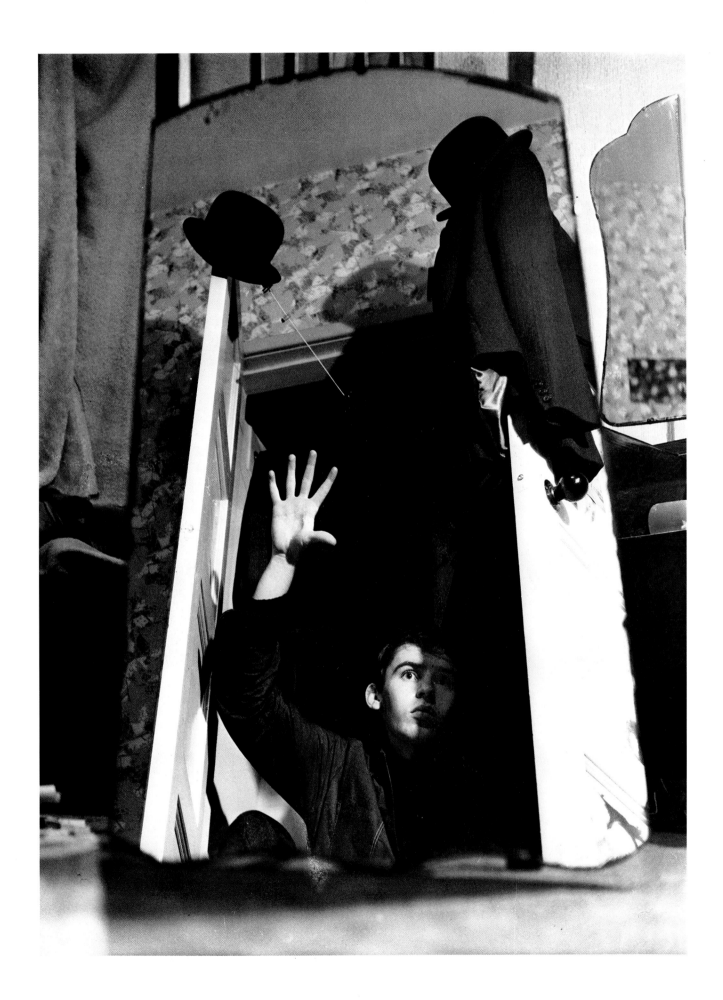

A Liverpool 'do'

Two peroxide blond, leopard-skinned soul sisters and a couple of tired and emotional 'Lads' at a typical Liverpool working-class party with Rory Storm (partially eclipsed by a flying saucer lampshade). When his father died, Rory and his mother committed suicide together. In later years I was joking lightheartedly about these two blondes in a Liverpool pub when the other male partygoer in this picture (second from left) said, 'Watch it, lar! I married one of dem.'

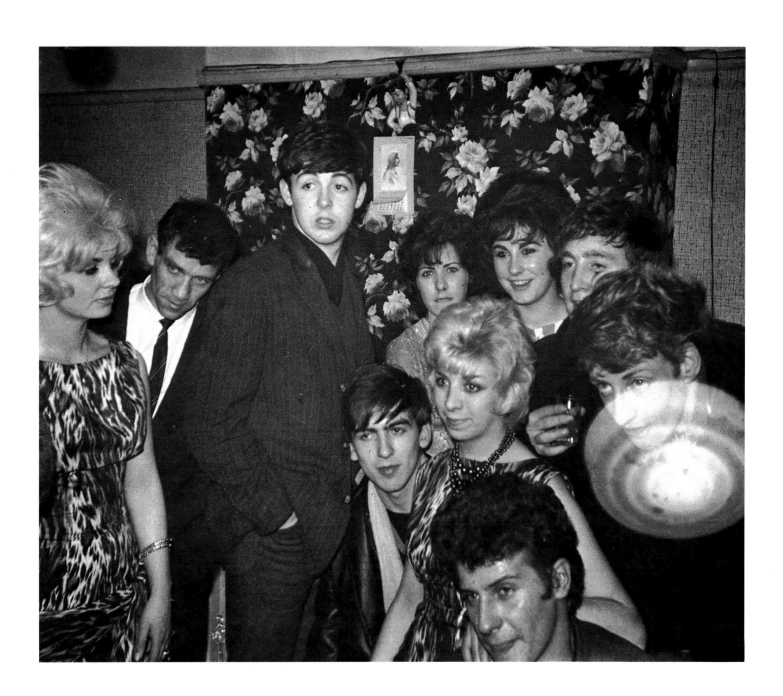

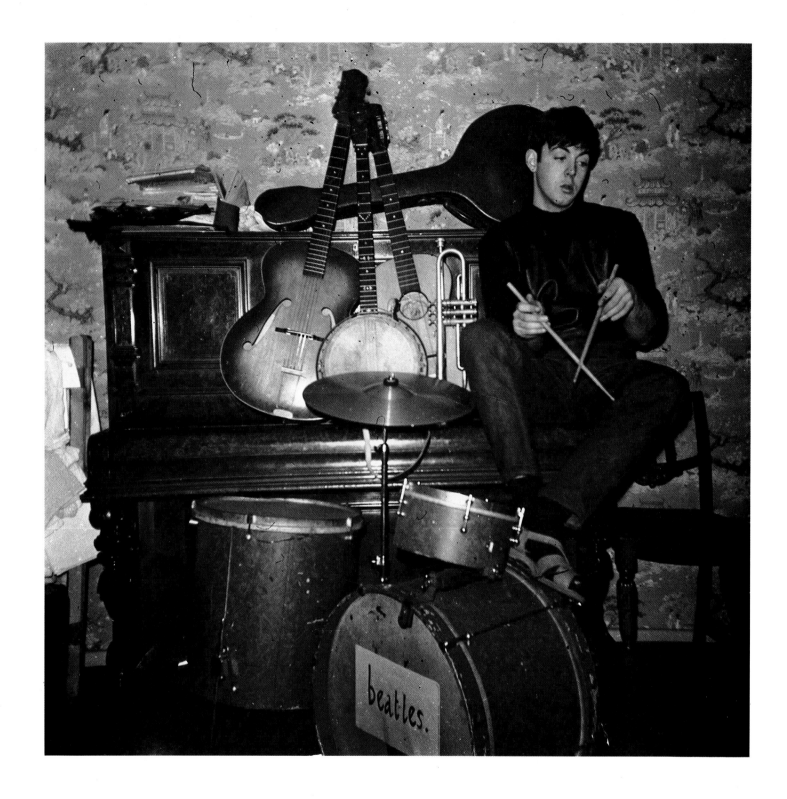

'Our kid' posing with water divining drumsticks on Dad's piano

One of Dad's great loves was music and in particular the piano, so at the least interest shown by us in any instrument…abracadabra, there it was! Hence the odd assortment of musical instruments on Dad Jim's piano – Paul's first trumpet from Cousin Ian and two guitars, plus my drums and banjo, all upstaged by the wooden family clothes-horse.

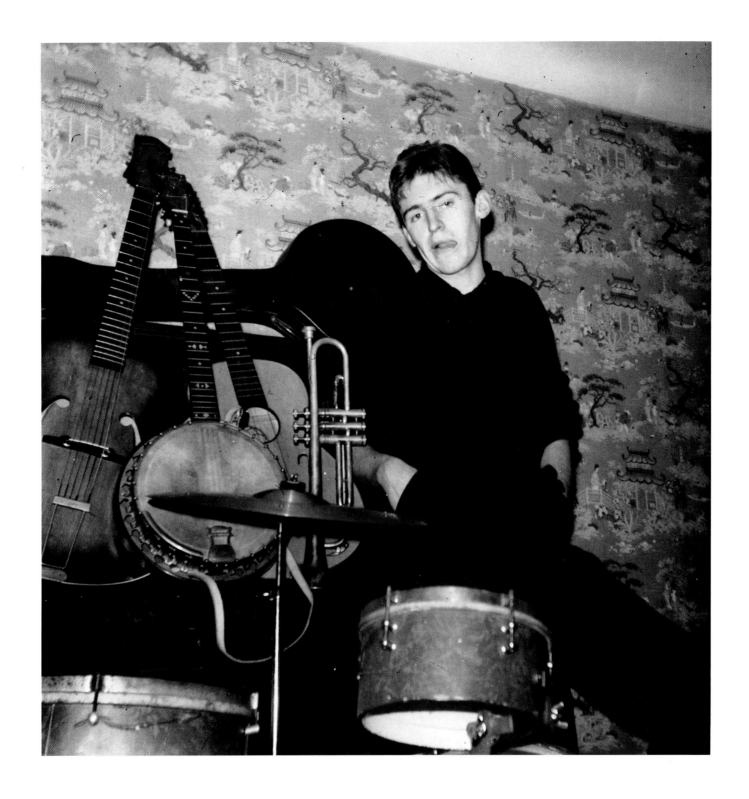

Brother Michael posing in the same set

Either Paul or Dad was pressing the cable release button. Note in the background the second, Chinese chippy-style wallpaper in one room. Keep turning for the third.

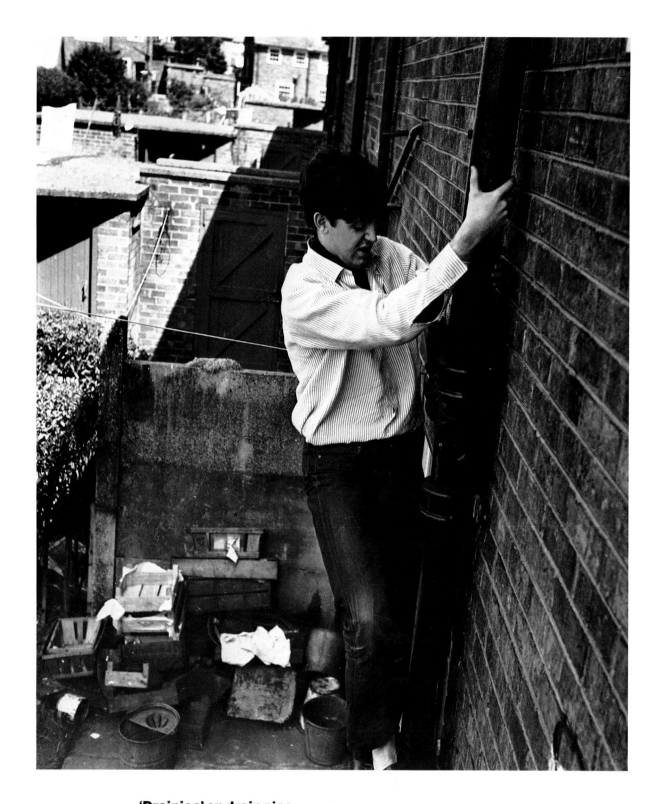

'Drainies' on drain pipe

Brother Paul climbing the back yard drain pipe. When we got locked out we had to climb up to the tiny toilet window and squeeze back in, head first (careful to avoid the bog!).

Right: Dad (practising his crossword and Morecambe and Wise routine) with eldest son in our Allerton back garden

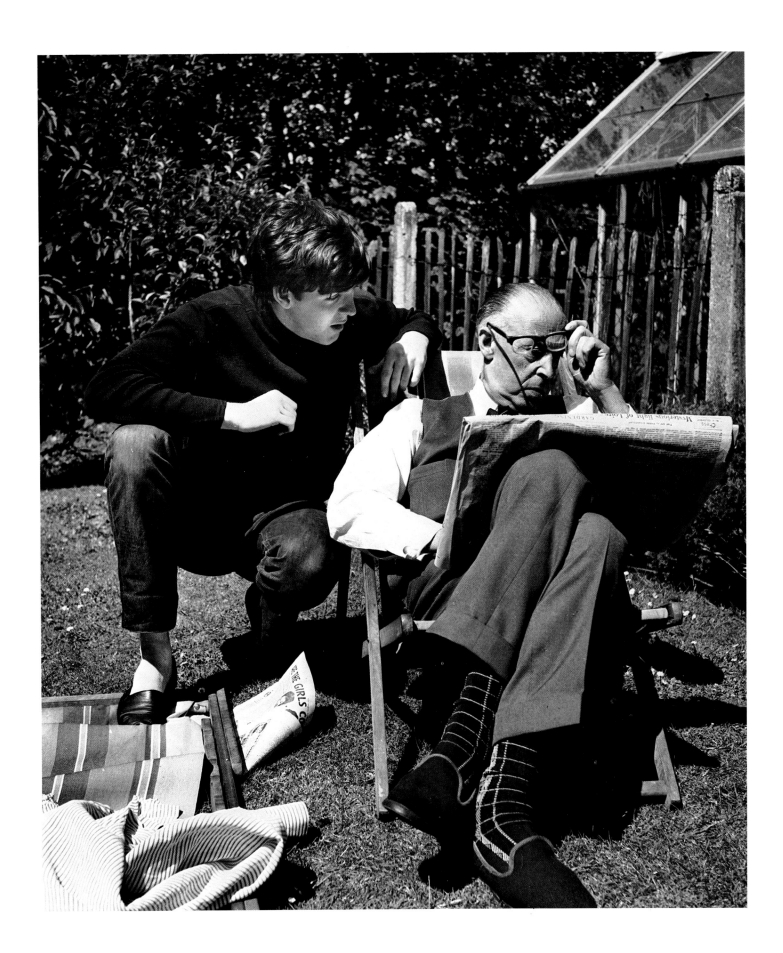

John 'poker-faced' Gorman guarding his Liverpool castle

Paul was warned to beware of his John. I was warned to beware of mine. Founder of the Merseyside Arts Festival, comic star of the Scaffold Tis Was and OTT…John Gorman, given the right material, was one of the naturally funniest men around.

Overleaf left: Paul with *not* so Long John Baldry, waiting to catch the train back to London

The photo is an optical illusion. John 'Hoochie Coochie' Baldry was actually about 6ft 7in. He used to come up to Liverpool to show off his beautiful oblique R and B records, as well as perform at the Cavern. He was one of Britain's best white blues singers, and a great influence on pop music in that after the Hoochie Coochie Men his 'Steampacket' group contained not only Rod 'the Mod' Stewart but also Elton John, who was so impressed with John Baldry that he took his Christian name for his surname.

Overleaf right: Nude statue and clothed Celia

After hitch-hiking down Germany from Cologne to Munich when I was nineteen I decided to visit Dachau concentration camp on the outskirts of Munich. My most haunting memory of the place was that even though the camp was in the middle of lush countryside, the birds refused to sing. This photo gave some much needed light relief after the visit.

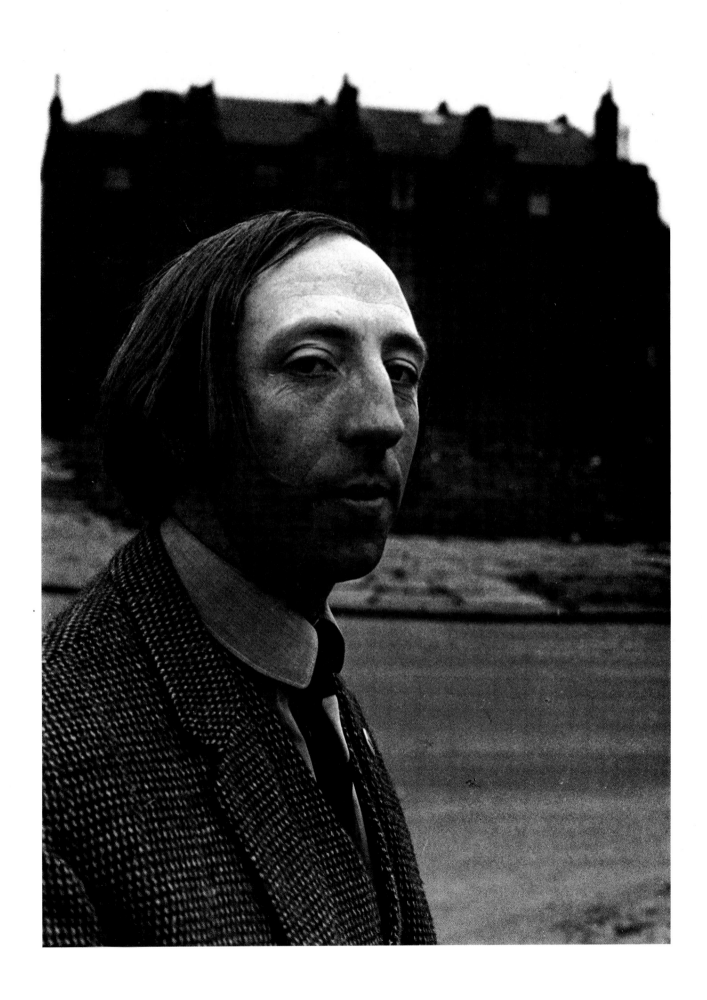

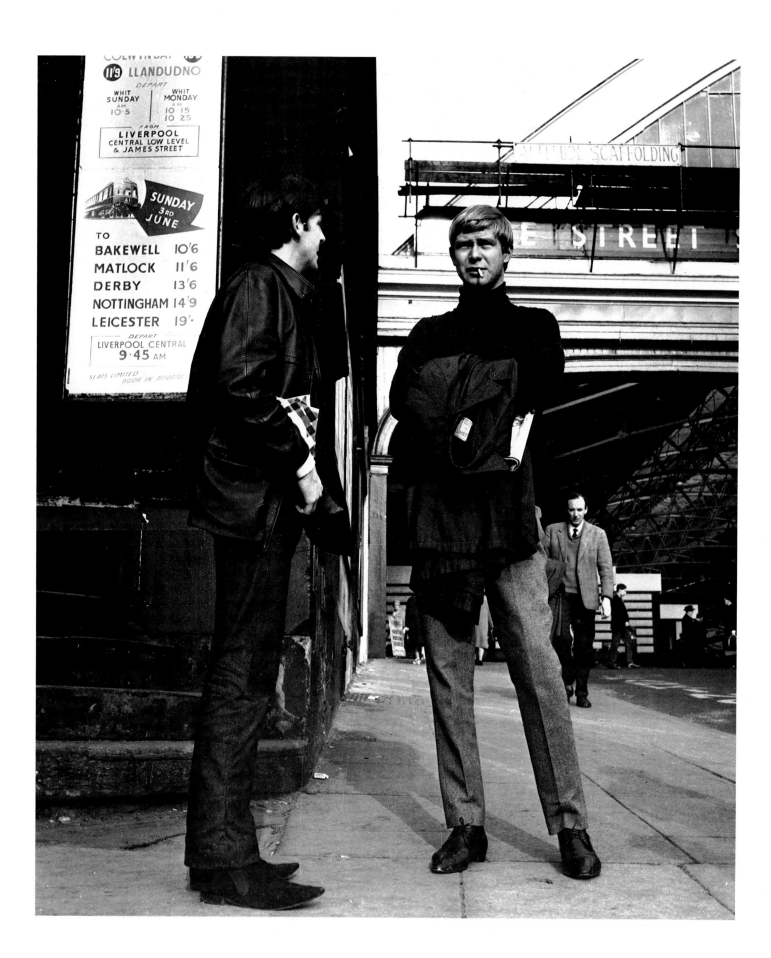

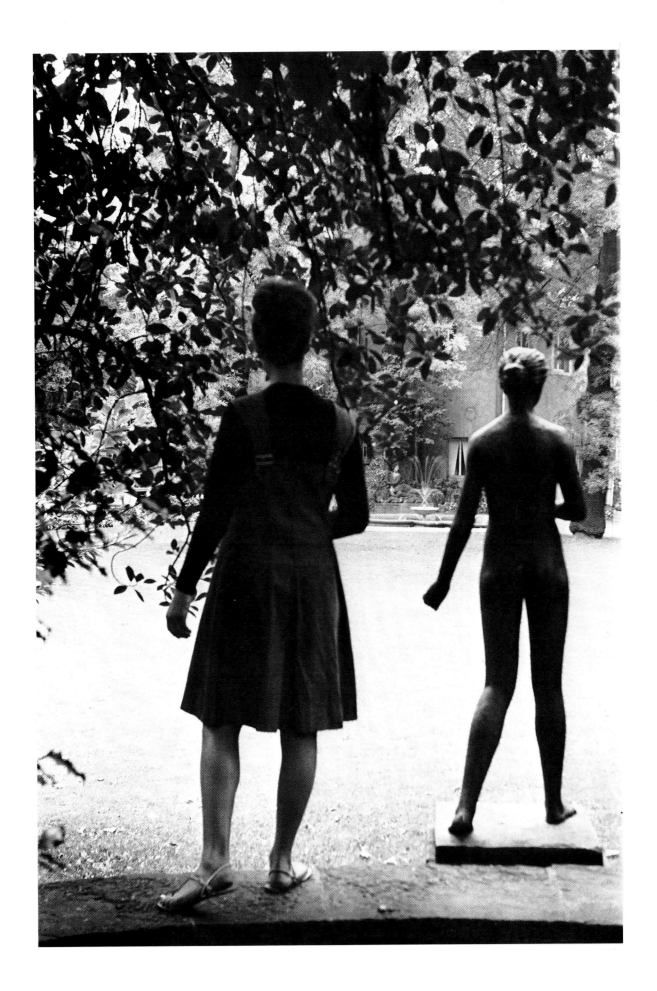

Rock Comes to Liverpool 1

John, Paul, George and Pete (Best) have their pictures taken with Bruce 'Hey Baby' Chanel and lead 'gob iron' (harmonica) player at the New Brighton Tower Ballroom, Merseyside, 1962. Although Hey Baby was a big favourite of ours, Bruce Chanel himself was a bit of a let-down for us 'rockers' as he turned out to be a nice all-American boy with a clean-cut jacket that could have come out of my André Bernard hairdressers!

Overleaf left: Rock Comes to Liverpool 2

'What are you doin' on top of that piano darlin'?' thinks the Sounds Incorporated saxophonist of his boss. A great front-of-house picture of the Tower Ballroom stage with one of our biggest rock heroes, the epitome of show biz himself, the Liberace of rock 'n' roll…Mr Little Richard.

Overleaf right: Rock Comes to Liverpool 3

An interesting photograph of Jerry Lee Lewis at New Brighton Tower, as he's not actually singing. When all the kids climbed on to the stage (including me!) he simply shouted, 'Get these —— kids off the stage or I ain't goin' on.' Behind Jerry Lee's microphone-clutching hand is part of Paddy the Cavern bouncer's head.

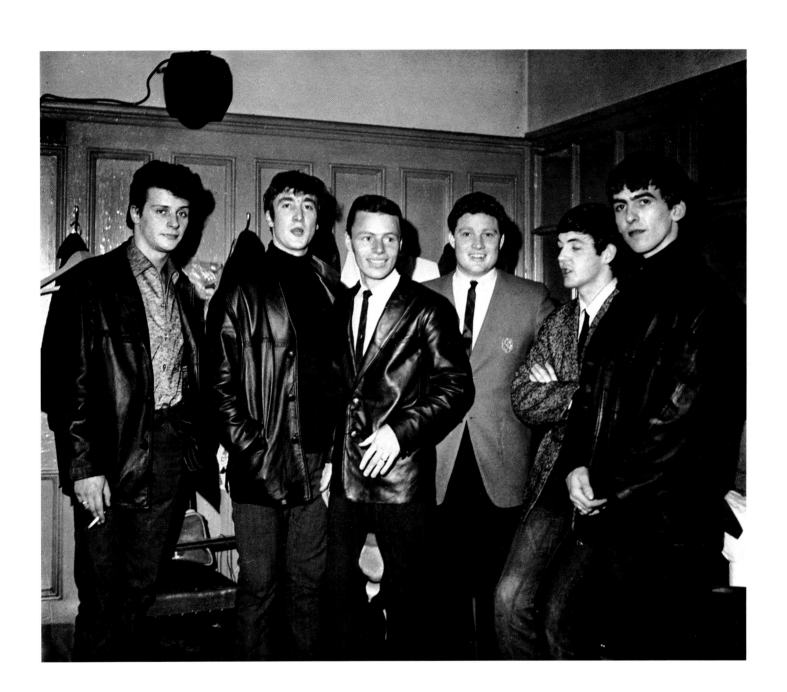

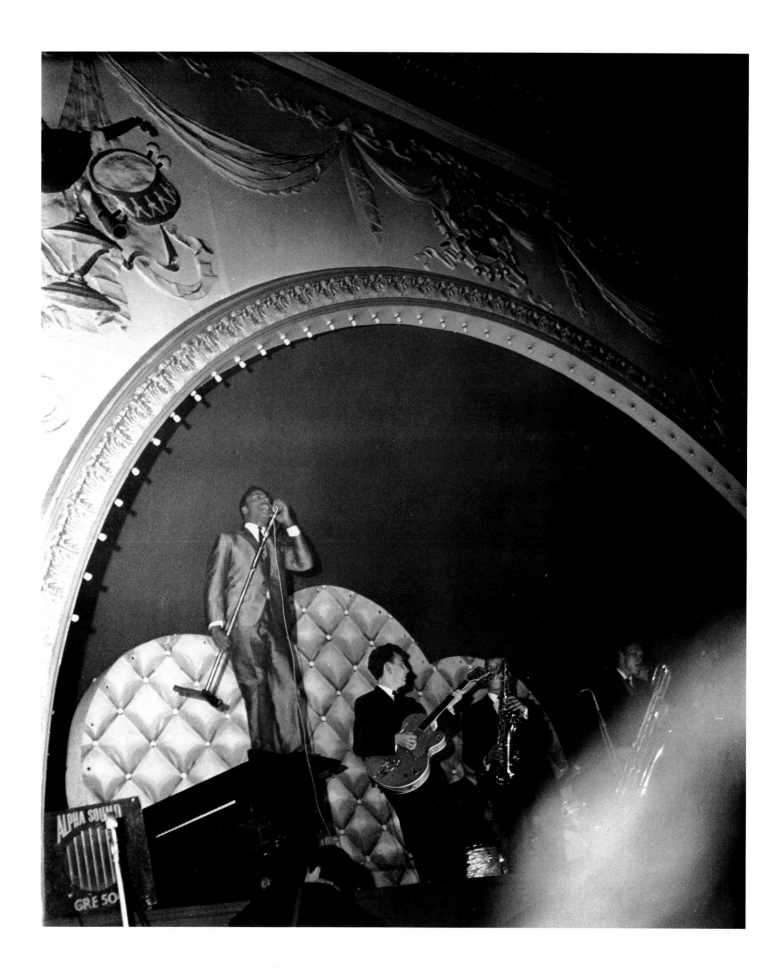

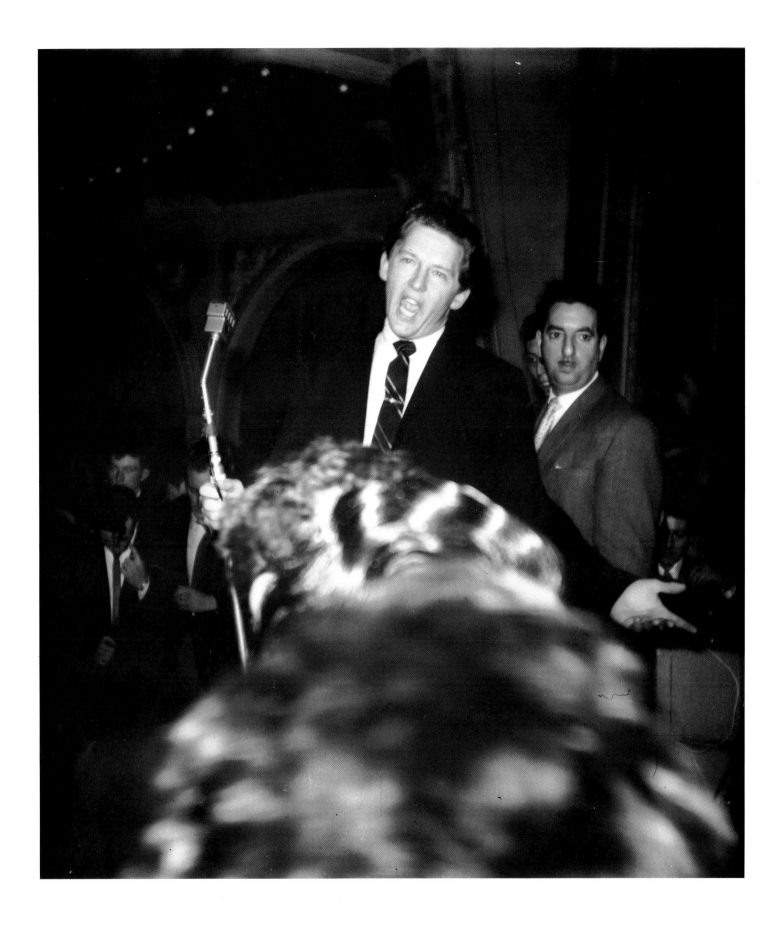

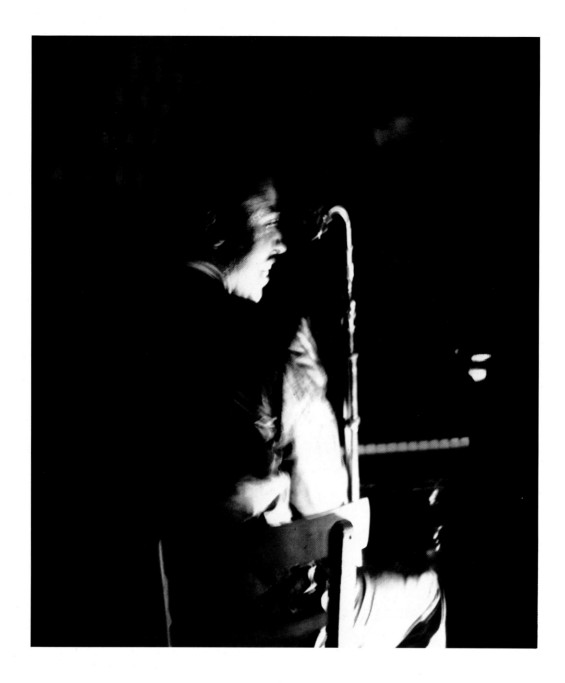

Rock Comes to Liverpool 4

Little Richard belting it out on the Tower Ballroom joanna (piano).

Right: Rock Comes to Liverpool 5

Of all the Beatles, Little Richard loved Ringo the best, so when he spotted Ringo and me through a small hole in the stage backdrop whilst he was performing, he would turn round every now and then to give us a little smile. Realizing that this would make a good picture, I put my Rollei Magic up to the hole. Unfortunately, because it was a twin lens reflex camera there was only room for the bottom lens to take the image, which meant I couldn't see when our idol turned round. So I put the camera on a tripod, gave Ringo the release cable, and peered over the top of the backdrop. When Little Richard turned to grin, I yelled *'Now!'* 'Pardon?' said Ringo. 'Click the shutter NOW,' I screamed. 'Oh,' said Ringo, photographing the back of Little Richard.

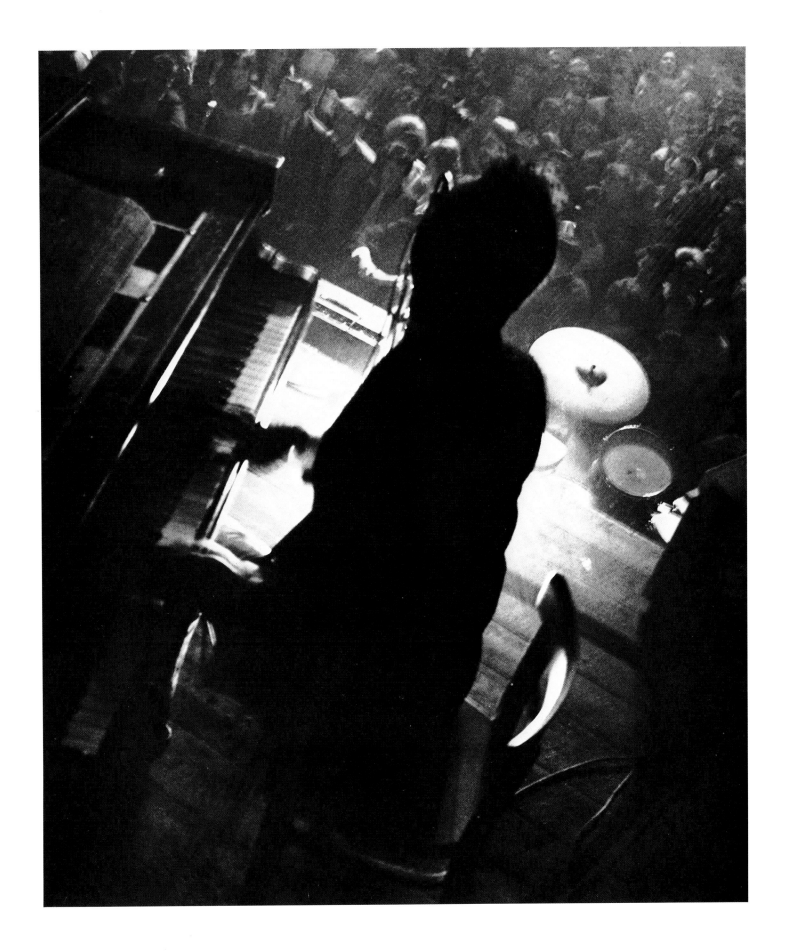

Big brother in back bedroom

A moody shot of Paul getting ready for a gig.

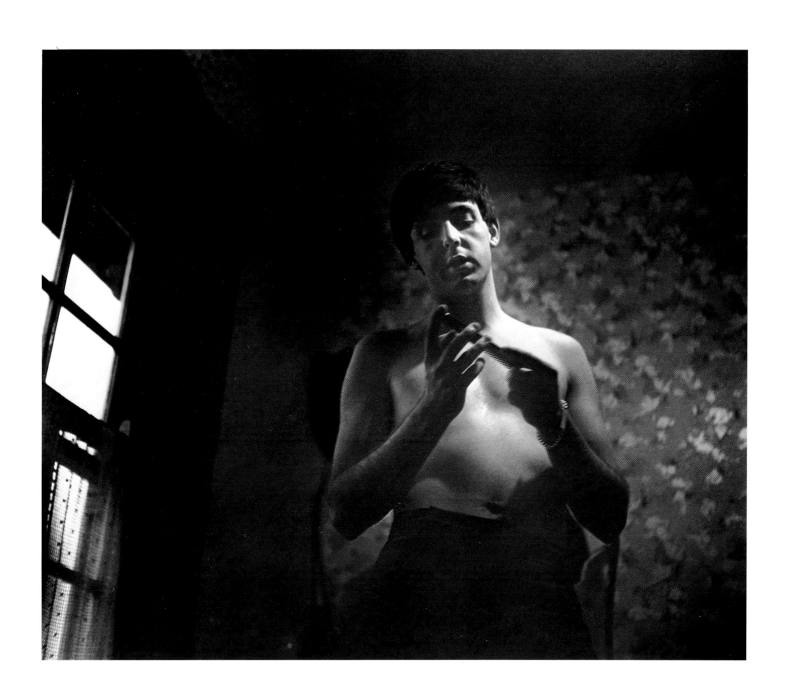

Marcel Marceau John, Rambo Paul, Goon Pete and nipple-shooting George

One of my favourite photographs of one of my favourite groups, taken in the now burnt down New Brighton Tower just after a show. I hope this fab pic conveys the feeling of how it actually was – relaxed, hopeful, spontaneous, positive, but most of all, FUN.

Overleaf: Three of a kind (plus Ray Charles, Peggy Lee and the MJQ)

Normal photographers have normal subjects to practise on ... the family pet (I had none), their parents (I had one) or grandparents in rocking chairs (I had neither), or sometimes nubile naked ladies (I was unfortunately too young when my hobby was at its height – photography, that is). So, after my brother and friends (who loved having their pictures taken) and Dad (who loathed it), I am afraid there was only me left! Hence all these mirrored images, in an attempt to get at least *one* shot where I look great.

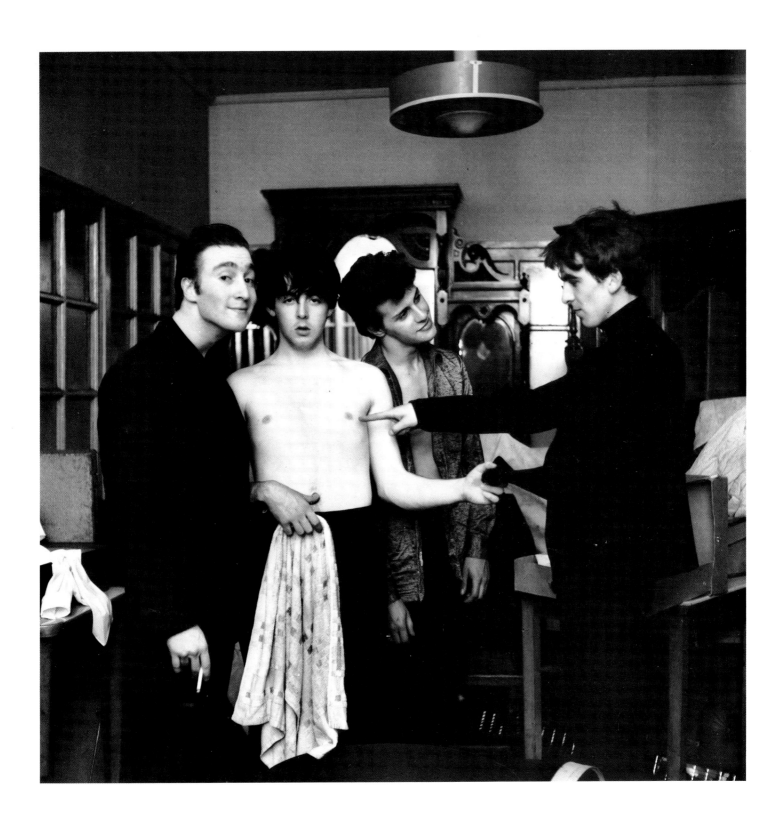

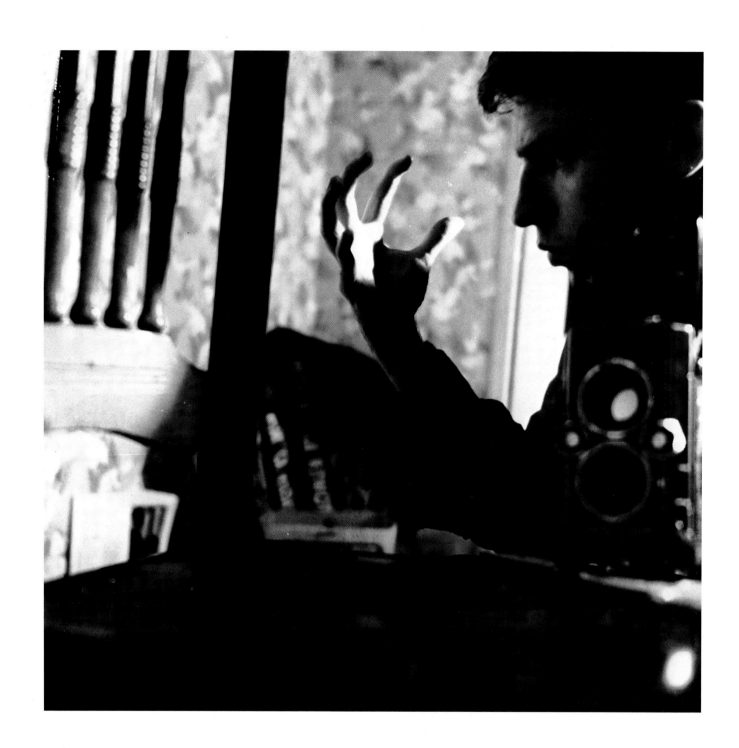

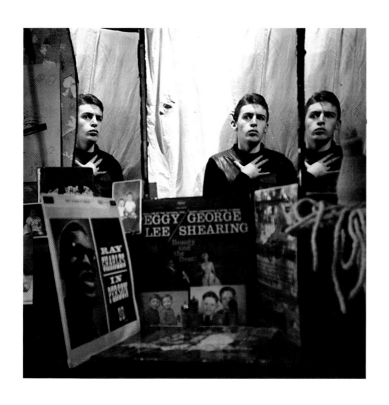

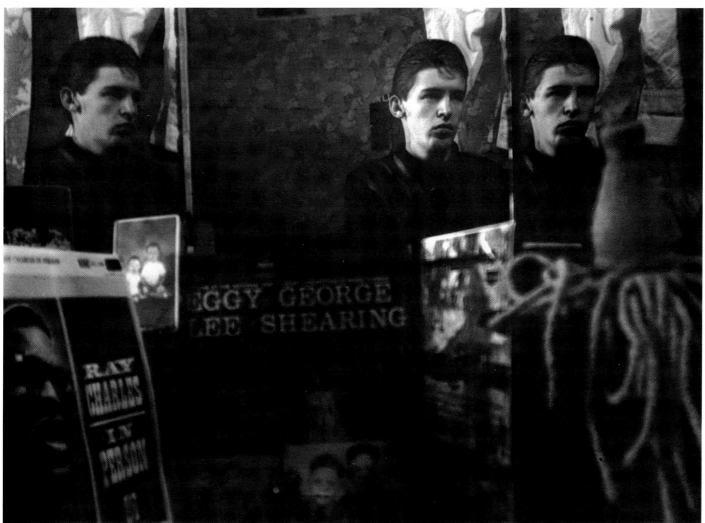

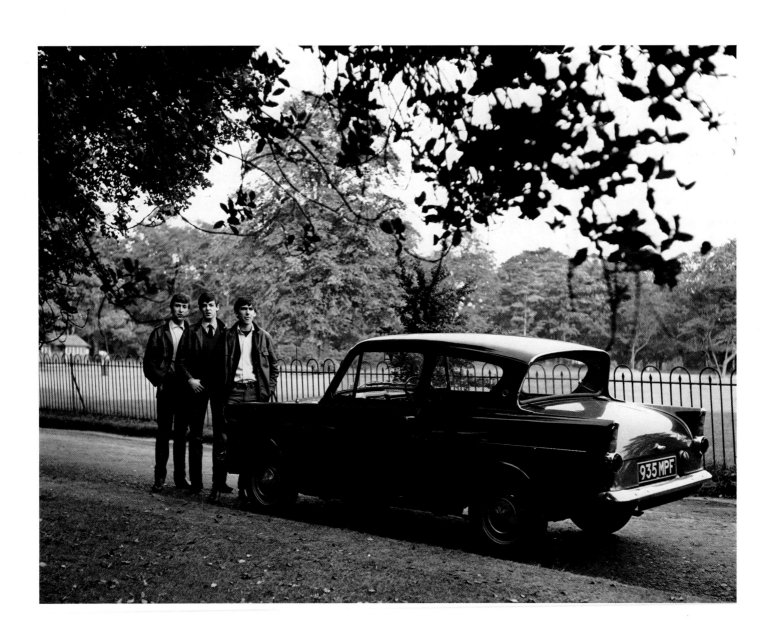

The Cars 1: A little light relief on the motorway

On the way to the match, the family lads take a closer look at nature. Cousin Ted was extremely annoyed at being pulled up by the police. 'Emergency stops only…Next time I'll book yer,' said the police officer. 'But that *was* an emergency,' said Ted. He was about to 'moon' at the police as they drove off, but we quickly pointed out that it might be wiser to wait until we were on our way back to Liverpool *after* the match.

Left: The Cars 2: The Big Time

'The Lads' posing with a Ford Anglia in Calderstones Park, Liverpool (Ringo's in the boot). The Anglia turned out to be George's, and last year someone informed me they had seen this photo in a newspaper advert back in the sixties. From what he remembered the caption to the photo read 'George of the Beatles buys his cars from Moisha Motors. Why don't you?' So that's where he got the money to start up Handmade Films!

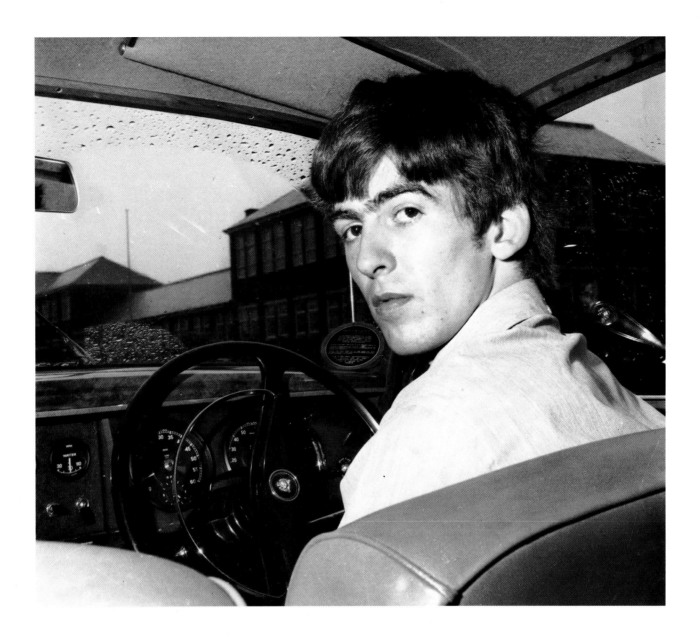

The Cars 3: George and the Jag on Mather Avenue, Allerton, Liverpool

When Paul gave me his green Ford Classic and bought a beautiful dark blue Aston Martin DB6, George was not to be outdone and one rather miserable Merseyside night he turned up on the doorstep of our Allerton home. 'Quick, Mike, take a pic of me with my new Jag.'

'But it's dark and raining,' I pointed out.

'Bring your flash and umbrella,' he replied.

Right: The Cars 4: Ringo seeing Starrs in the back of 'our' first Ford Classic

I had often commented to Paul what a versatile and inventive drummer the bloke with Rory Storm and the Hurricanes group was, so it was great news when Ringo finally joined the Fab Three. He was lucky that one of the best drummers on Merseyside had just broken his arm…me!

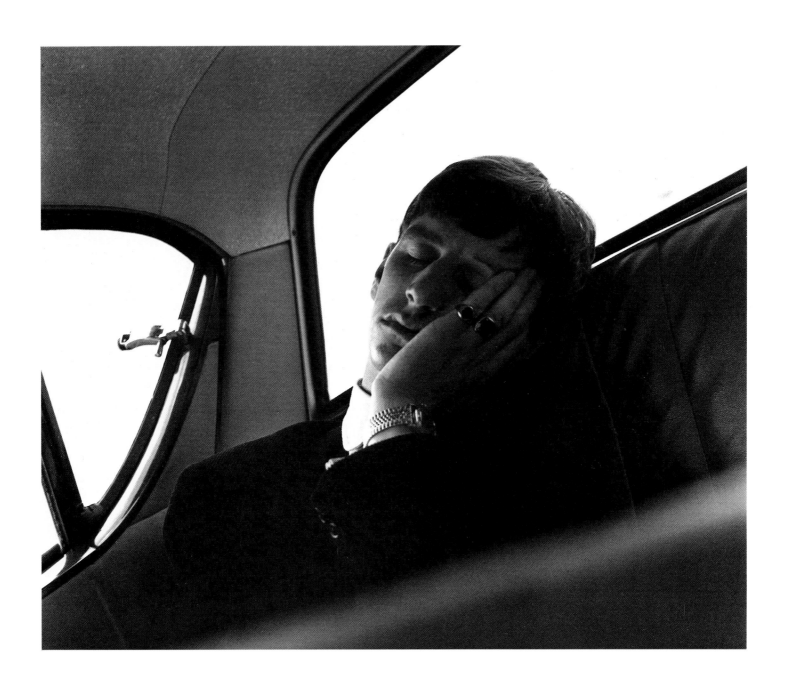

'It's OK, he's armless'

Breaking in my new Nikon camera. This was the birthday present from Paul which became the source of inspiration for the first pop hit (written by me) of my comedy group Scaffold, 'Thank U Very Much', which became Prime Minister Harold Wilson's favourite pop song.

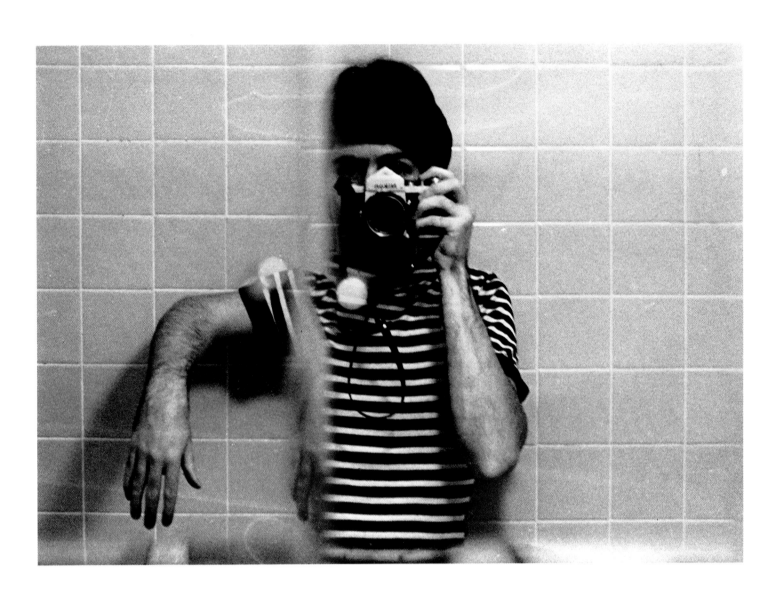

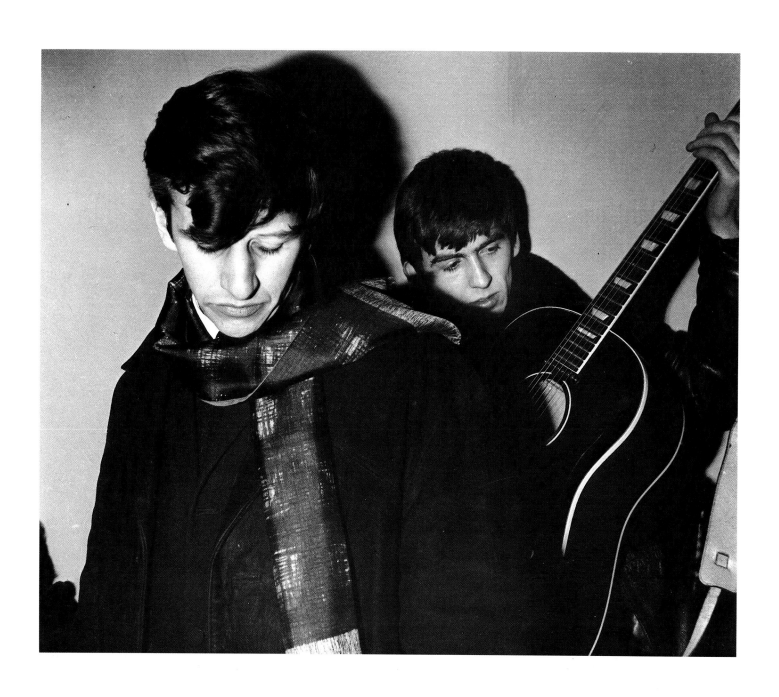

The Wrexham Leaders 1: Front mugshot of Ringo and George

These two shots were taken to illustrate an article about the Fab Four by David Sandison of the *Wrexham Leader*, North Wales.

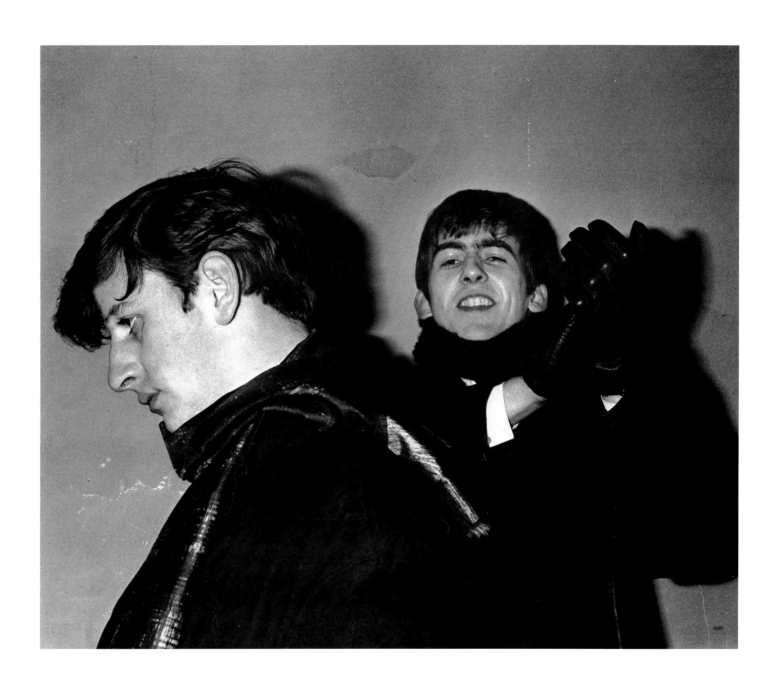

The Wrexham Leaders 2: Side mugshot of Ringo and George

The scarf Richy (Ringo) is wearing was passed on to Paul, who passed it on to me, who lost it.

The Lone (St)Ranger, home, home on the Allerton range...minus Tonto

A framed picture of brother Paul taken from our Forthlin dining-room window through Mum's curtains, plus washing and clothes prop.

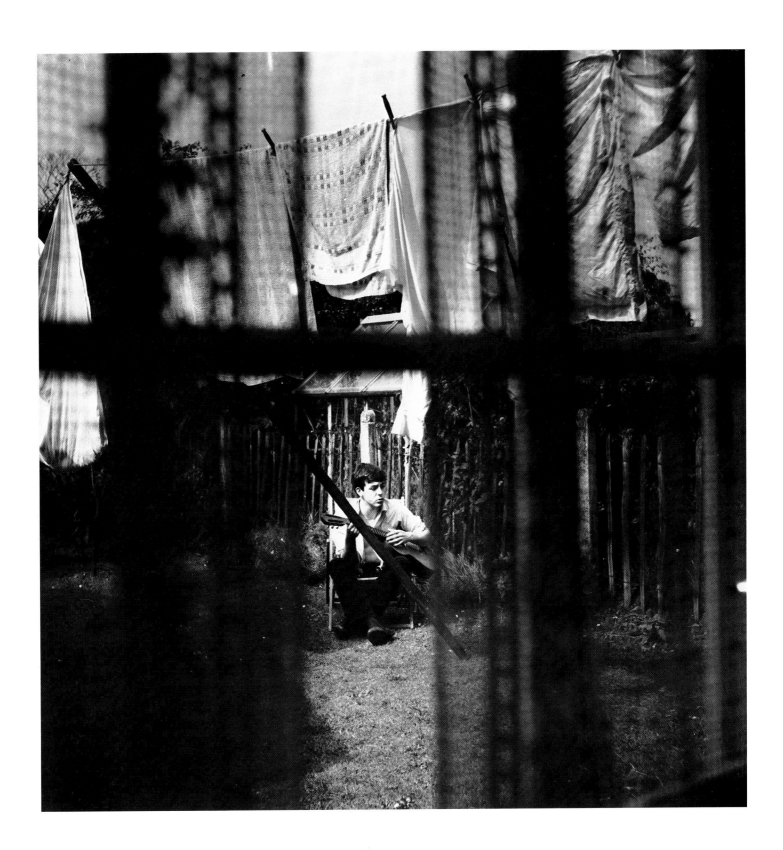

Doing the crossword

Dad in the front parlour of our Allerton home. As I've said, Dad was not over-enamoured with having his fab pic taken, so I had to sneak a shot whenever possible. This photo was taken in his favourite armchair, behind which is his eldest son's first proud gold disc. Dad's head is resting on the anti*macas*sar crocheted by our Aunties Jin and Mill to stop our Brylcreemed hair from oiling the chair. But their pièces de résistance are the covers on the arms of the chair, hand-made to prevent the bare springs ripping our clothes to shreds.

Overleaf left: The Rodgers and Hammersmif of pop

Two of the world's greatest songwriters, Lennon and McCartney, rehearsing 'I Saw Her Standing There' from Paul's Liverpool Institute High School book. It is coincidence that the book was open at that page (you can *just* make out the song title … if you are an ant) because this is one of the few songs that actually made it. Being professionals even then they decided that the rest of the songs were not up to standard, so they never saw the light of day.

The off-cuts of carpet under their feet were to hide the holes in the floor, and hold on – is that the third and final striped wallpaper in the one room?

Overleaf right: Out-of-focus heroes

With subjects like the Beatles, Little Richard, Gene Vincent, it's easy to skip through the pages and miss everything else. The close-up on a guitar is to remember the days when a guitar was just as important as a rock 'n' roll hero (and I hope still is).

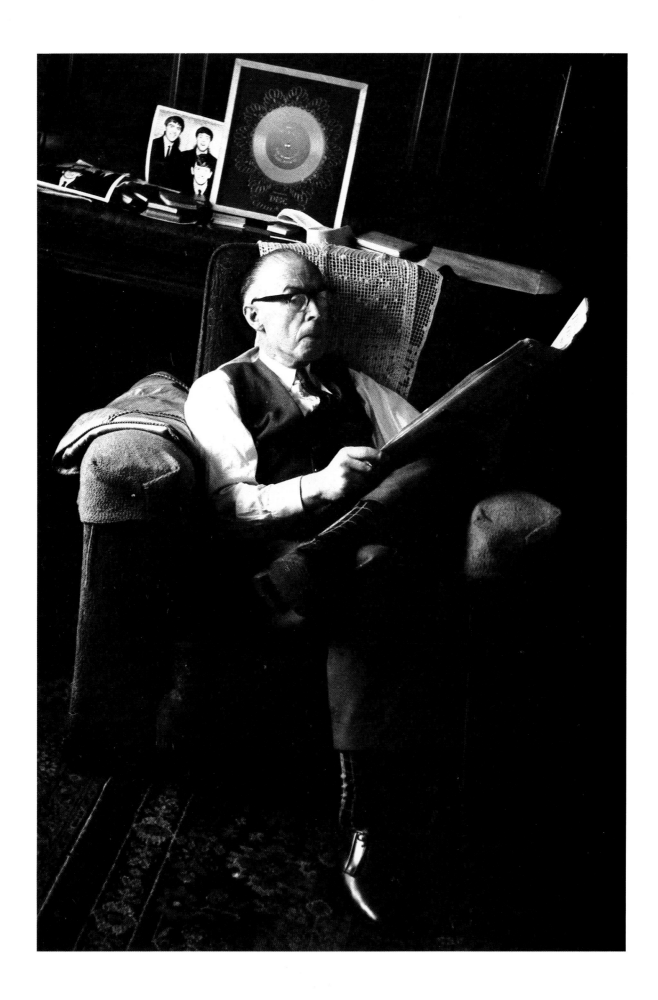

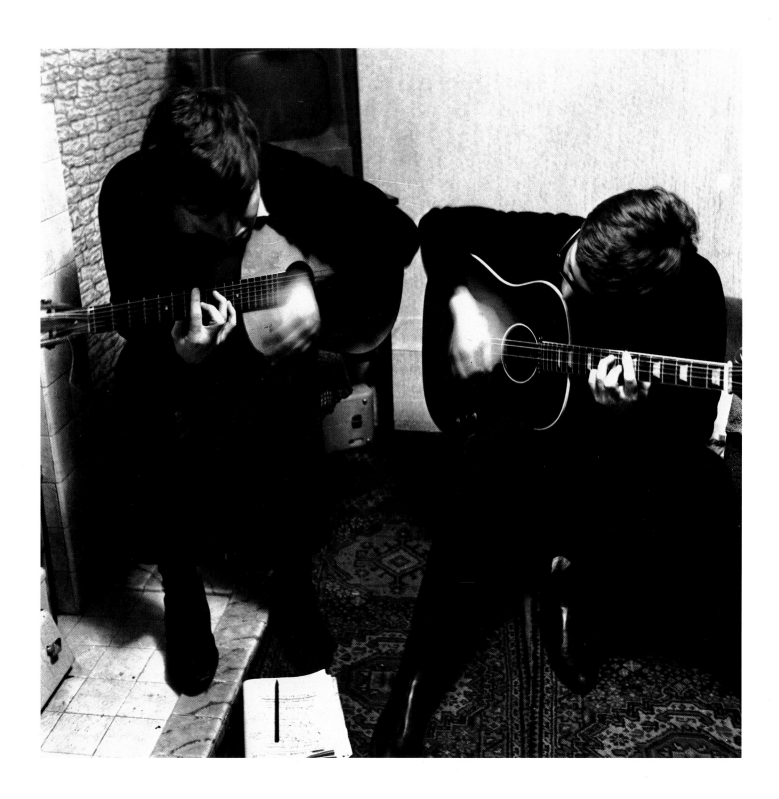

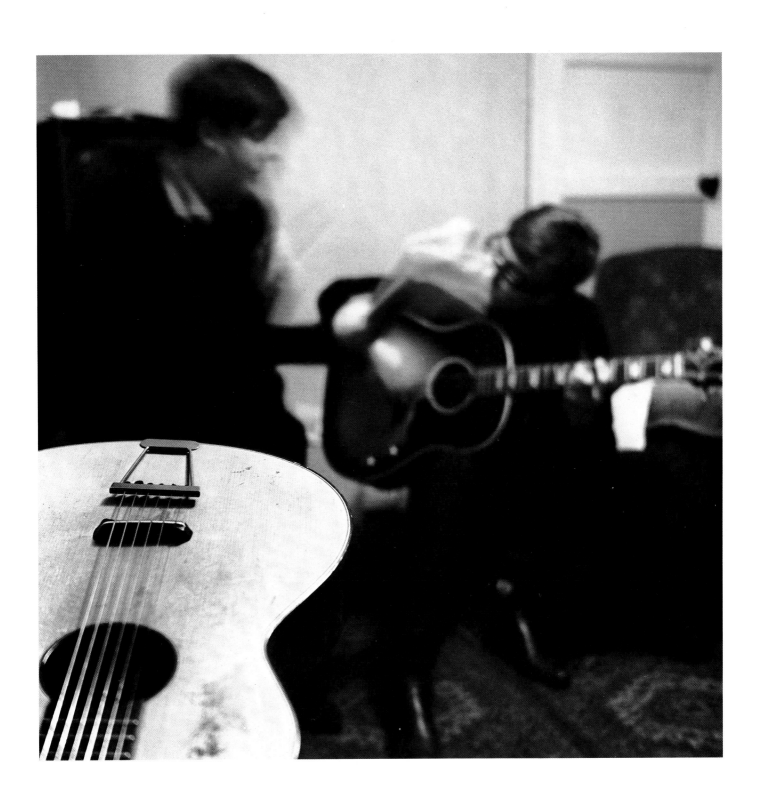

Paul McCartney's floating head

On my Rollei Magic I discovered that winding off the 'automatic' setting, a lot of light came into the camera at 3.5 and a small amount entered at 22 – i.e. the shutter stayed open. So I started to experiment. With a black backcloth, and having asked Paul to wear his black polo-neck sweater, I positioned two naked light bulbs behind the camera and with the help of a tripod and a cable release (plus a very *still* brother) achieved this shot.

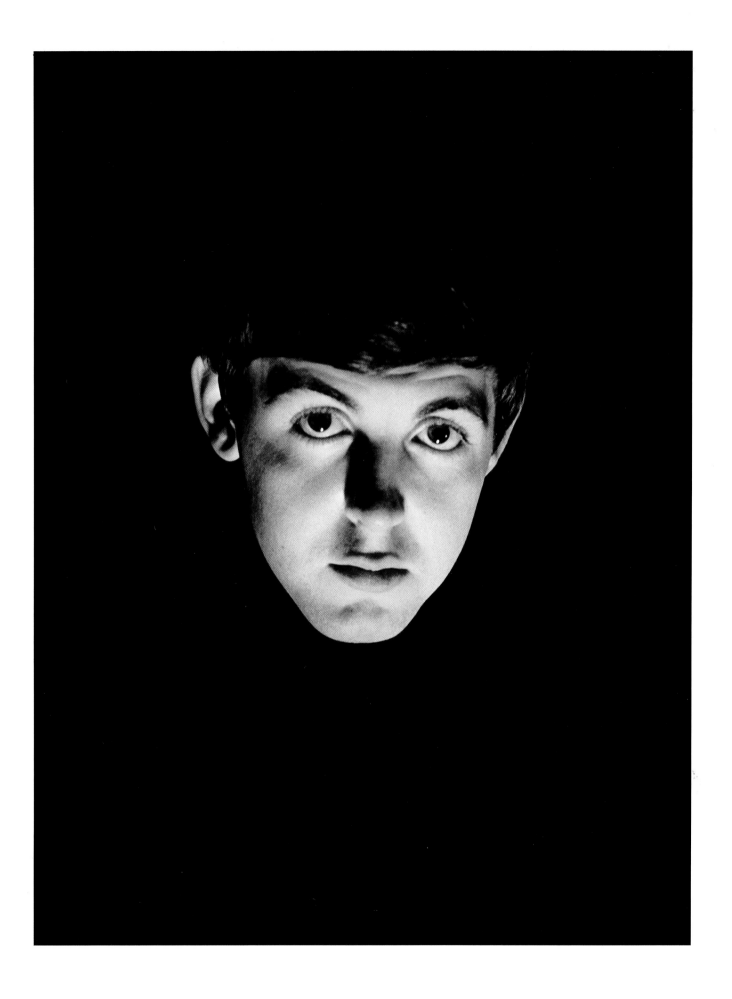

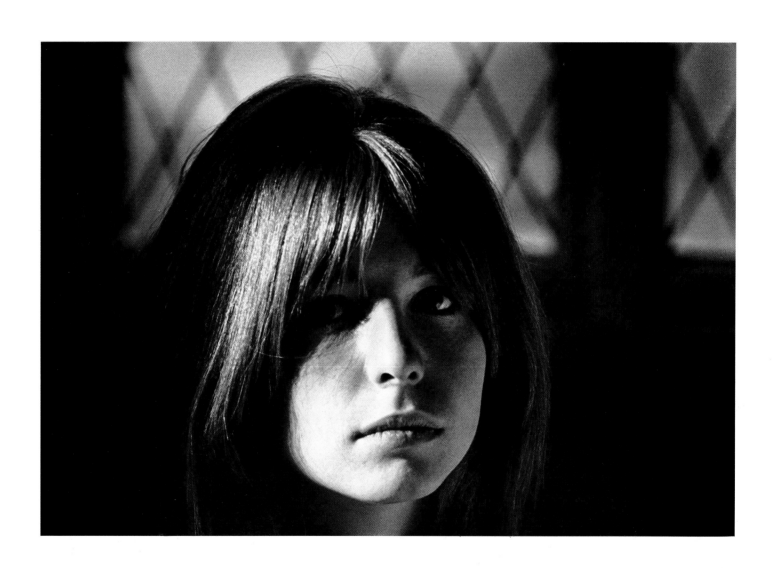

The Girls 1: Jane

A naturally lit portrait of actress Jane Asher, taken on Merseyside in one of our Liverpool homes. As we only had black and white television it was quite a shock to find that in the flesh she had rich orange hair.

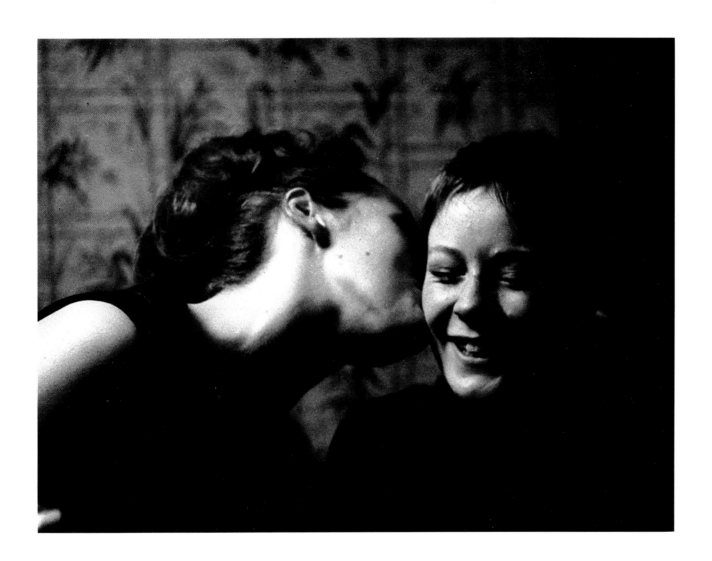

The Girls 2: A kiss from one good friend to another

Taken at Paul's 21st birthday party in Aunty Jin and Uncle Harry's home, Huyton, Liverpool.

The Ouija board

This was taken in the Captain's cabin of the Mersey ferry *Royal Daffodil* on a 'Riverboat Shuffle', sharing the bill with jazz clarinettist Acker 'Stranger on the Shore' Bilk. (Luckily he made it to the boat.) As you can see from the picture, Paul, George and a very intent John are attempting the supernatural. If only they'd told us you have to put your hands on the *glass!*

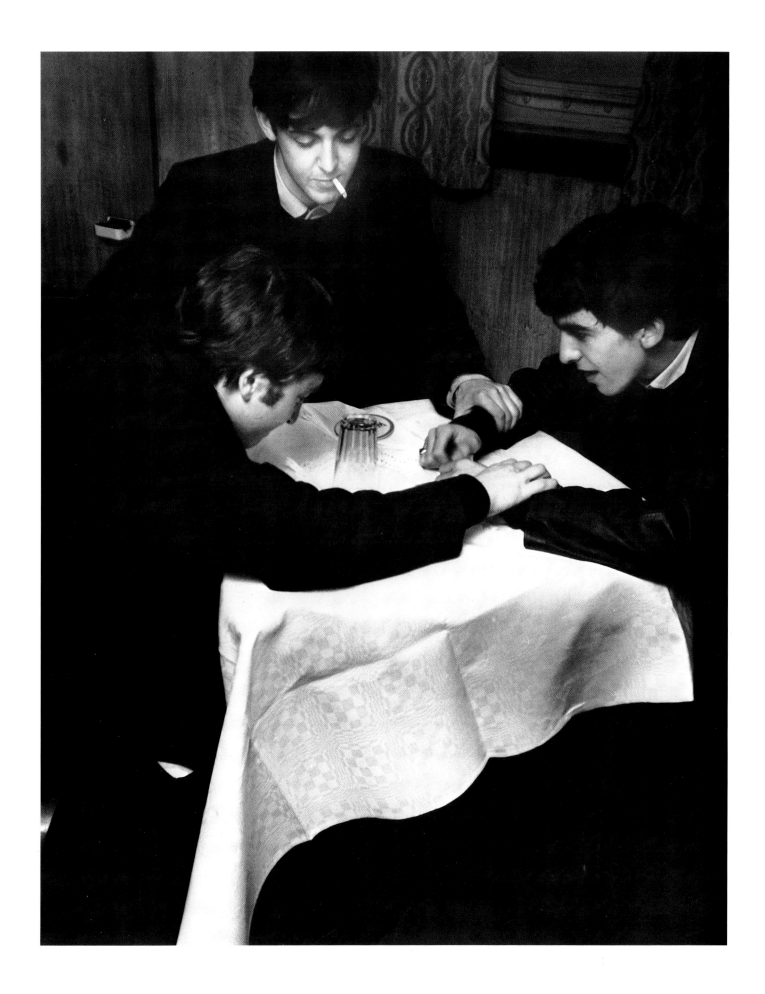

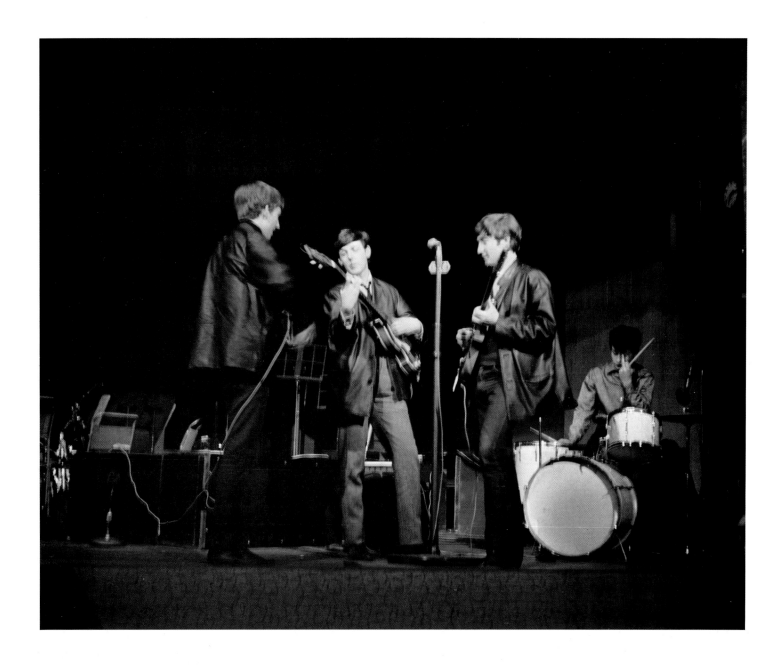

The Peter Pilbeam Show 1

I was in between jobs as a Catholic Bible representative or ladies' barber when I sagged off (took a day off work) to attend the rehearsals in Manchester of Paul's first 'Peter Pilbeam Show' on BBC radio. This was probably one of Pete Best's last gigs before Ringo took over.

Right: The Peter Pilbeam Show 2

Bird's-eye view of first radio rehearsals, leather-clad. For the actual evening transmission they all wore mohair suits (on radio!).

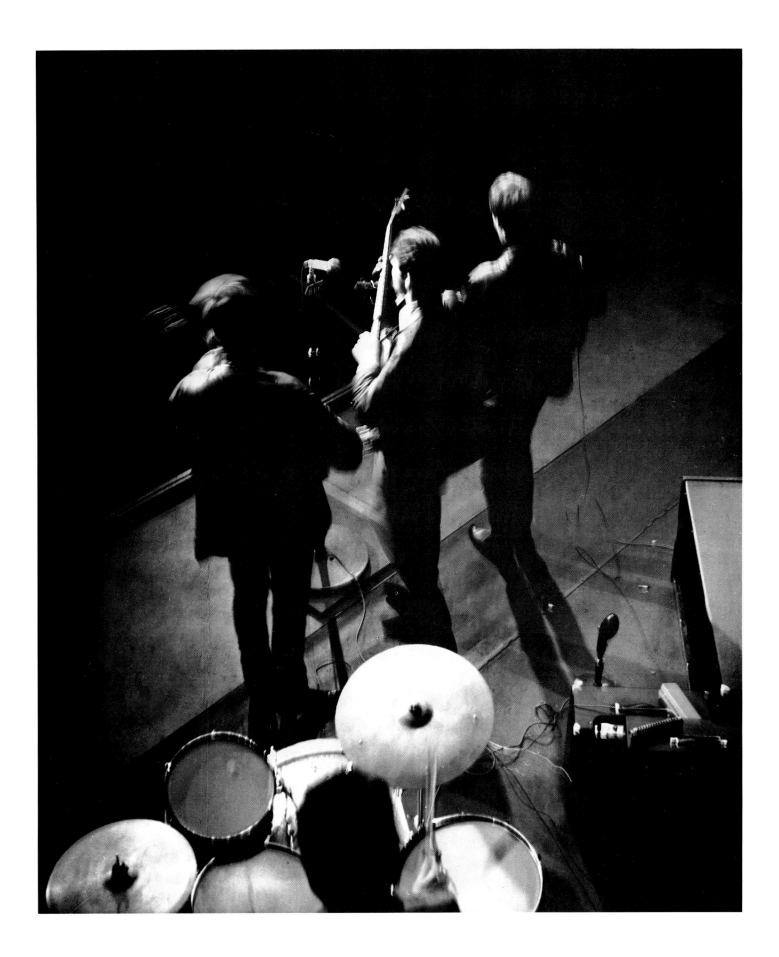

SGT. PEPPERS NELY HEARTS UB BAND ghost upstages the Magrittes

Overleaf left: Claes Oldenburg's *Bent Saw*

Scaffolders Roger McGough and John Gorman with Buzzy Lindhart and bass player in the Peggy Guggenheim exhibition, New York. (My first view of the great Bill Brandt's work was just round the corner.)

Overleaf right: Josh in the Giant's Garden

Our three-year-old son resting at the International Garden Festival, Liverpool.

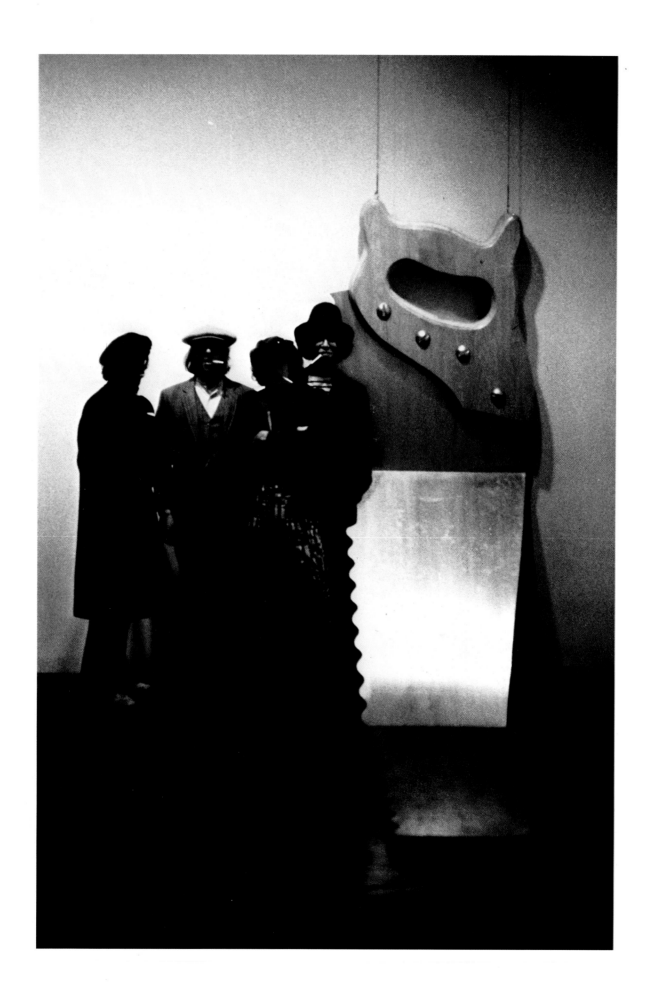

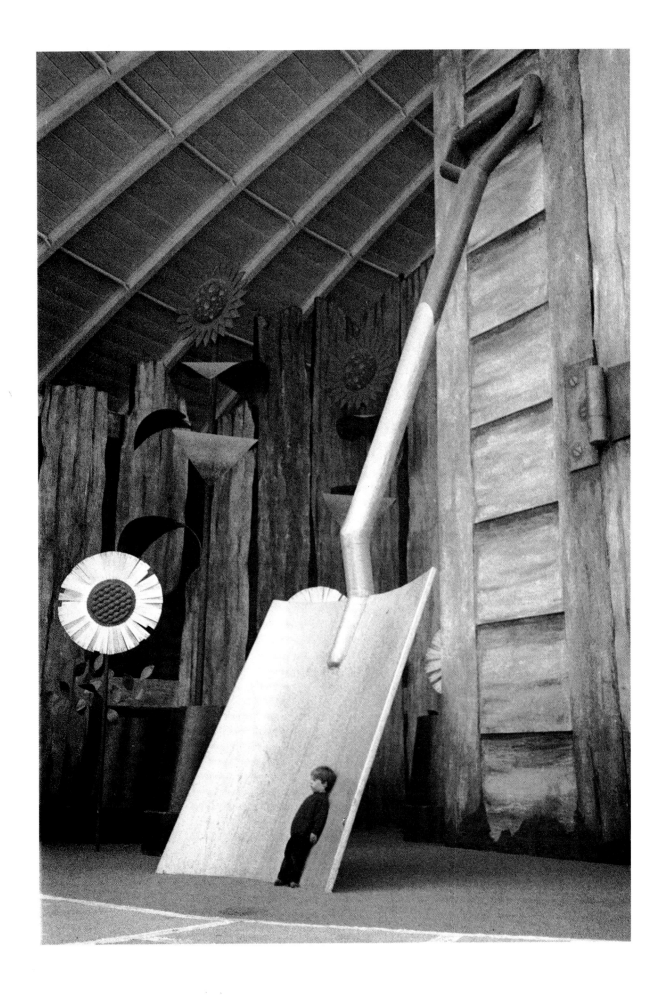

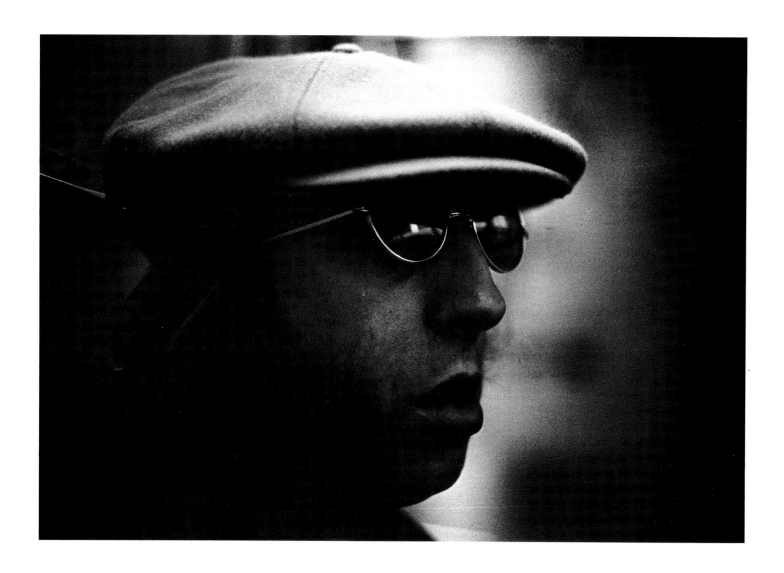

A shady John Gorman plus sunglasses and 'Apple' cap on a daytime New York subway

Because of possible muggers in the Big Apple, the three Scaffold members (John Gorman, Roger McGough and yours truly) stuck together as much as possible on journeys to and from performances at the 'Bitter End' of Greenwich Village, and the umbrella I carried everywhere was only partially for rain…it was mainly to fence off the muggers.

Right: Three Lively Whacker Wits on the way home from a Peter Stringfellow booking in Sheffield, Yorkshire

Scaffold had several pop hits in Britain, including 'Thank U Very Much' – after which my book was writ – the big number one hit 'Lily the Pink' and Dominic Behan's 'Liverpool Lou', but the mass audiences never saw the *real* Scaffold, who were actually best at poetic word imagery sketches and university-style surreal and satirical humour. Unfortunately these were always the *next* 'That Was the Week That Was', Monty Python and so on, i.e. too far ahead for their own good – or as Eric Clapton would say, 'Too clever by half'.

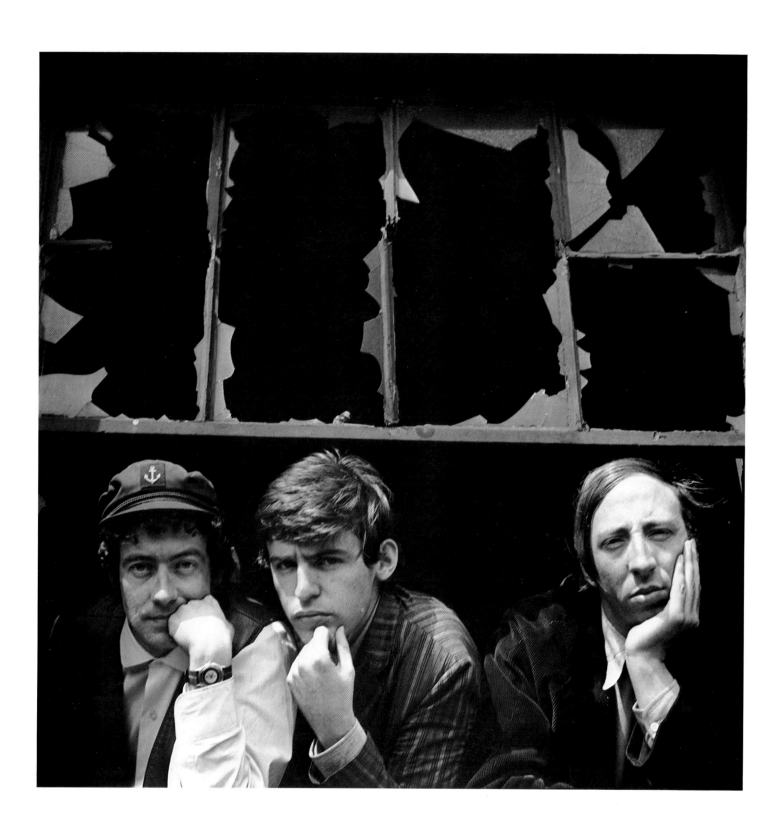

Beirut before it blew up

An image taken through the window of the Intercontinental Hotel, Beirut, from the outside, with Dad watching TV on the inside in our hotel room – well before the troubles. We should have had some inkling of what was to come when, passing a hillside covered with corrugated iron roofs where the Palestinian refugees lived, we asked the taxi driver what the small hole in his windscreen was. 'It is just a small bullet hole, no problems,' he explained. 'Marhaba.'

Overleaf left: The Sun 1: Young man relaxing by the pool

Overleaf right: The Sun 2: Young man relaxing *on* the pool

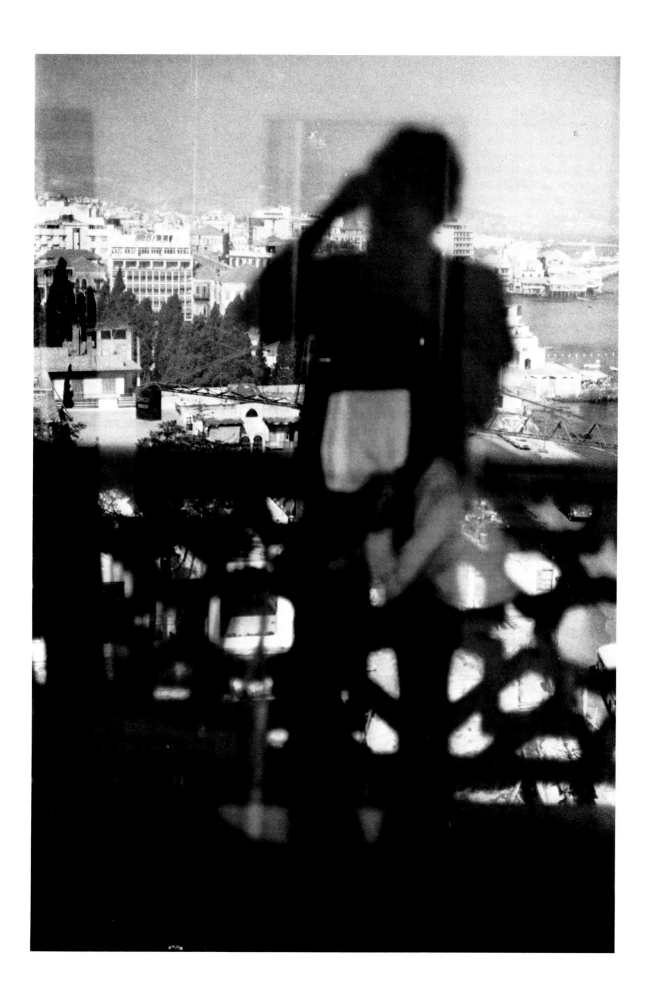

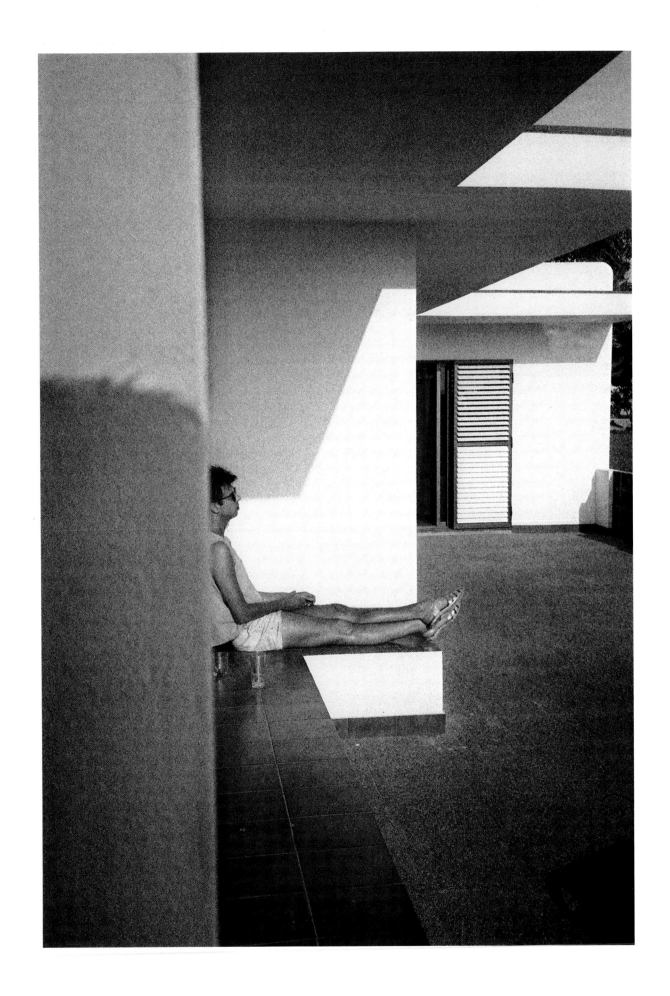

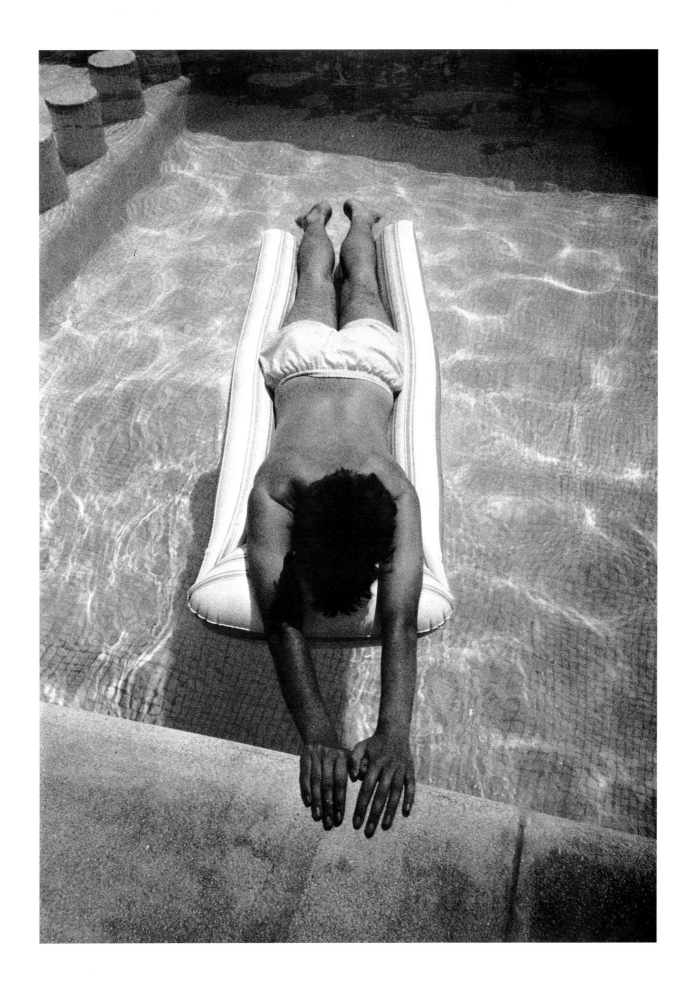

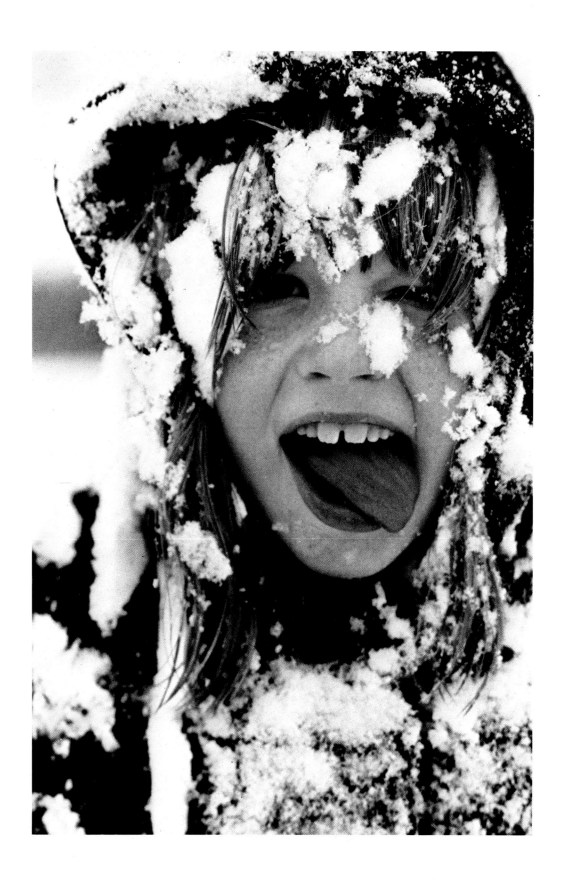

Abbi Snowmass

The youngest of my three daughters, Abigail Faith McCartney, in the role of Snow White on the banks of the River Dee, Heswall, Wirral.

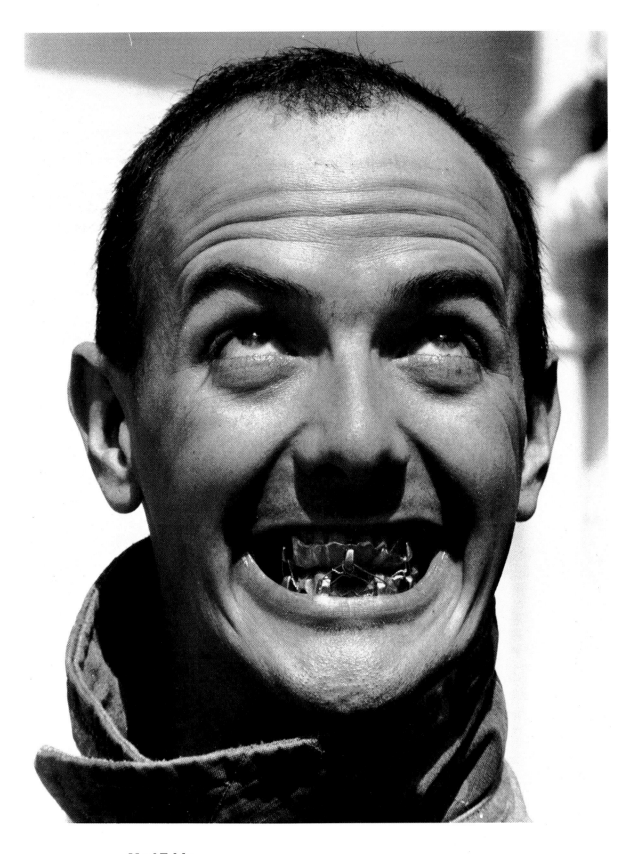

Mad Eddy

My wife Rowena's old school chum Chris (Eddy) Edwards showing off his broken jaw, or a gun running SAS fighter with heavily reinforced steel teeth to bite the enemies' heads off. Take your pick.